IMAGES
of America

ESTACADA

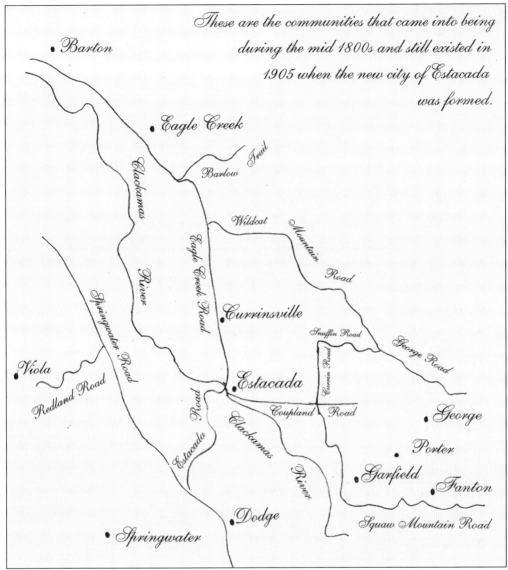

MAP. The entire area shown here is often referred to as Estacada. Although it is the only incorporated city, longtime residents still identify with the unincorporated surrounding communities where they live. This map, drawn by the author, shows the physical relationship of each town to the city of Estacada. (Courtesy Kathryn M. Hurd.)

ON THE COVER: When settlers arrived in the mid-1880s, abundant old growth Douglas fir trees were felled to open land for farming, mill lumber for building, and burn wood for warmth. As time went on, all the trees were harvested. In the early 1940s cleared land became profitable for growing fescue grass seed for golf courses and lawns. Another excellent source of income, beginning in the 1950s, was raising registered Hereford beef cattle. Alta fescue hay, which had some food value, could be used as part of their diet. Elwin Shibley, mounted on the horse on the right, surveys the family's Herefords eating fescue hay. His brother Everett Shibley stands by the last "big one" cut down on their Springwater property. Everett's daughter Winnifred and son Gilbert pose on top of the six-foot diameter stump. (Courtesy Wilma Shibley Guttridge.)

IMAGES
of America

ESTACADA

To Christine Steele
Writers Record History
People Make History
Enjoy!

Kathryn Hurd
3/10/12

Kathryn McCune Hurd

ARCADIA
PUBLISHING

Published by Arcadia Publishing
Charleston, South Carolina

Printed in the United States of America

Library of Congress Control Number: 2011932608

For all general information, please contact Arcadia Publishing:
Telephone 843-853-2070
Fax 843-853-0044
E-mail sales@arcadiapublishing.com
For customer service and orders:
Toll-Free 1-888-313-2665

Visit us on the Internet at www.arcadiapublishing.com

To the residents of Estacada who care about preserving their history

CONTENTS

ACKNOWLEDGMENTS

I extend deepest gratitude to residents of the Estacada area who were willing to share private family photographs; these account for most of the images in this book. Some, living outside the city and state, sent photographs of relatives who lived here in the past. You are the ones who made this book possible. Bob Akins (BA), Barb Hicks (BH), Barr Collection (BC), Beth McKinnon (BM), Cheryl Guffy (CG), Cody Collection (CC), Charlie Whitten (CW), Don Cole Family (DCF), Dorothy Generaux (DG), Duane Kiggins (DK), Dwyer Family (DF), Estacada Fire Department (EFD), Gilbert Shibley (GS), Glen Wolcott (GW), Jane Park (JP), Jack Reynolds (JR), Jack Kellendonk (JK), Jeanne Holden (JH), John Englund (JE), Kathy Guthu (KG), Kevin Ekstrom (KE), Luwana Hansen (LH), Miller Family (MF), Mossy Rock Gifts/Marilyn O'Grady and Milan Paterka (MR), Nancy Tucker Tedrow (NT), Reliance Connects/Brenda Crosby (RC), Rick Fridell (RF), Cat Rhea and Cheryl Klawitter (RK), Ruth Lazott (RL), Sylvia Bowman (SB), Springwater Store/Ron Carroll and Jeong Yon Lee (SS), Squaw Mountain Ranch (SMR), Terry Tracy (TT), Wilma Shibley Guttridge (WSG), and William Sager (WS); Portland General Electric (PGE) and Jacknife-Zion-Horseheaven Historical Society (JZH) willingly opened their files for reproduction of pictures in their collections.

Bill Klaetsch, Bill Ray, Bob Brown, Bonny Wojdan, Clackamas County Family History Society, Connie Redmond, Craig Humes, Dennis Dahrens, Dorothy Sahr, Dottie Wonser, Eagle Creek Elementary School, George Suter, Gloria and Jerry Polzin, Jackie Rice, Jim Buhlinger, John Rhodes, Katrine Barber, Ken Wilson, Leroy W. Layton, Linda Forsberg, Melanie Wagner, Michele Kinnamon, Mike Whitten, Millie Kiggins, Norm Christensen, Herm Saunders, Betty Marlowe, Lilyanna Johnson, Nubez Jordan, Ruth Cromer, Anna Stavinoha, and William Elliott provided historical information.

Jack Reynolds, the Miller family, Nancy Tedrow, Ruth Lazott, Sylvia Bowman, Wilma Guttridge, Robert Steele, Ede Andrede, Steve Cox, Deb Shallert, and Joanne Broadhurst were especially generous with their time and historical facts.

Jordan Winthrop, Canaan Winthrop, and Nathan Cooper (technical support), Mitch Luftig and Laura Whittemore (editorial assistance), Lee Meiers (LM), and Michael Dille (MD; photography) are gratefully appreciated.

Special credit goes to my Arcadia Publishing editors—Sarah Higgenbotham, Donna Libert, Devon Weston, Tiffany Frary, and Shayne Ross—for their invaluable suggestions and support.

INTRODUCTION

The city of Estacada, incorporated in 1905, is located in the foothills of the Cascade Range in Clackamas County, Oregon. Approximately 30 miles southeast of Portland, Oregon, Estacada is reached by traveling a winding two-lane road along the scenic Clackamas River. While just over 2,400 individuals live within the city limits, the remainder of the total population of over 18,000 resides in the unincorporated towns surrounding it. This is a diverse area. Historically, sources of livelihood included agriculture, logging and milling, and a variety of recreational opportunities—hiking, camping, boating, hunting, and fishing. Recently, the economic base has widened to include the Christmas tree industry, metal fabrication, and a growing arts community.

The original inhabitants were the Clackamas people, part of a larger group of Native Americans called Chinook, who developed a tribal language referred to as Chinook Jargon. This was basic, readable, and easily understood, and was used by tribes up and down the Pacific Coast and eastward into the Plains. With no source of metal, they were ingenious in using stone to make weapons and tools. The Clackamas thrived but were decimated by white man's diseases—a deadly smallpox epidemic in 1824 was followed by malarial fever in the 1830s that killed 80 percent of the population. "The surviving Clackamas people were relocated to the Grand Ronde Agency under the Willamette Valley Treaty of March 3, 1855."

In the 1850s, immigrants as rugged as the landscape converged on the 750 square miles of fertile land around the Clackamas River, settling in eight separate towns. Before the beginning of the 1900s, all of these communities were thriving and self-sufficient, with stores, churches, and schools. Roots run deep and memories are strong. Even today, residents identify with the community in which they live. Early settlers believed in integrity, independence, and honest labor—values that formed the character of the future city of Estacada.

Early settlers considered education to be of utmost importance, so once a community formed, starting a school was a priority. A single teacher taught grades one through eight in a one-room school. By the 1940s, it became more difficult to find willing teachers for the small, rural grade schools, so the outlying communities began consolidating with the Estacada School District. Some parents saw it as an opportunity for students to expand their horizons; others missed the closeness engendered by a small rural school, remembering their own schools with nostalgia.

Estacada owes its existence to the construction of four hydroelectric power dams along the narrow canyons of the Clackamas River during the early 1900s. The city of Portland, hungry for electric power, grew increasingly reliant upon an extensive electrified network of trolleys for transportation.

Many companies formed the foundation for the filling of this great need. Through a series of purchases, mergers, and cooperative ventures, the assets of 28 predecessors were gathered into entities known variously as: Oregon Water & Power Company (OW&P), Oregon Water Power & Railway Company (OWP&R), Oregon Water Power Railroad Company (OWPRC), Portland Railway Light & Power Company (PRL&P), Portland Electric Power Company (PEPCO), and Portland General Electric (PGE). The names may have changed, but their goals were the same—to

generate power from the Clackamas River. The first construction was completed in 1907 and the last in 1958, and all are now owned by PGE. The construction of so many dams on one river was a great undertaking. The Clackamas has been referred to as the "Dammed-est River in Oregon."

In 1903, the OWP&R laid rails up the Clackamas River in order to move supplies and manpower for the building of Cazadero Dam and Faraday Powerhouse. The Oregon Water Power Townsite Company was formed to capitalize on the railroad by selling land and creating a town below the dam. An advertising campaign was formulated to use the interurban line to draw potential landowners up the river. On December 27, 1903, four men each placed a proposed name for the new town into a hat. The name drawn was Estacada, although there is a century-long controversy over the word's meaning, with numerous emotional documents attesting to the "truth." Speculation still exists and always sparks a lively conversation. Nonetheless, once the name of Estacada was accepted, the real work of building a town began.

As early settlers arrived, nearly every farm had a small mill for cutting timber into boards that could be used to build homes, barns, and fences. As harvesting accelerated, larger mills emerged to process the huge quantities of lumber for sale. The extension of the railroad up the Clackamas River was a boon for companies who found it much easier to take trees out of the mountains when they could ship them out on flatcars. Once the rails were taken out, the new road—built on the railroad bed—proved an equally convenient, although hair-raising, transportation route.

Loggers were a breed apart—powerful, fearless, and ready to prove their strength, even in the town's taverns. For eight decades, logging was the main industry of Estacada. Major logging operations, numbering 25 by the 1950s, took advantage of the abundant timber. During the summer months, hundreds of trucks passed through Estacada daily (estimates vary from 200 to 700). Each truck averaged a load of 5,000 board feet per day. Although timber still emerges from the mountains of the Mount Hood National Forest, the era of big operations up the Clackamas is over.

After clearing the land, building houses, and constructing schools, early settlers turned their attention to creating incomes through firewood, lumber, grain, animals, and cured meats. In the 1880s and 1890s, farmers invested in commercial orchards containing apples and plums. In the early 1900s, the advent of the railroad line promoted loganberries, gooseberries, and strawberries, which were sold to canneries and wineries. A number of hop fields supplied breweries. Ginseng fields stretched up Reagan Hill and on the slopes leading to Springwater. By 1950, farmers began profitably raising beef cattle that foraged on the land, which meant an area-wide decline in raising and harvesting grain for livestock. Growing grass seed became a moneymaker in Springwater, and around 1980, the attention of farmers in every district turned to raising trees. Some now refer to Estacada as the "Christmas tree capital of the world."

Historically, residents of Estacada treasure festivals and the parades that accompany them. In 1923, the Springwater Grange started a tradition with an annual fair, held every September, to showcase agriculture in the community. From 1958 to 1982, the Estacada Timber Festival, developed to help commemorate the lure and art of logging, was a popular and enduring event.

Vortex I, a state-sanctioned gathering created to avert a potentially volatile confrontation between the American Legion and the People's Liberation Army, focused the eyes of the nation on Estacada; some thought of it as a West Coast Woodstock. A number of smaller events, which may not have the largest billing but are memorable in their own right, have caught the attention of people who enjoy the unique.

Estacada is unlike any other town. Its rich past has brought it to a present filled with cultural events, recreational opportunities, and continuation of the spirit of those who made Estacada a reality.

One

ORIGINAL INHABITANTS

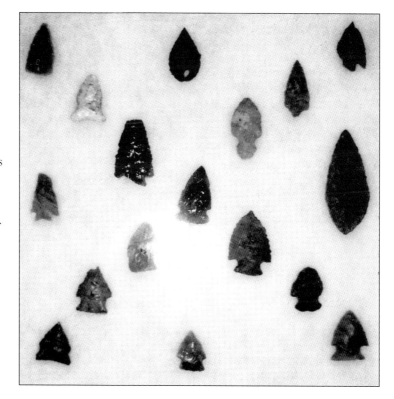

ARROWHEADS. The indigenous Clackamas people, the original inhabitants of this area, left many artifacts as evidence of their presence. They had no metal and made all implements from stone. Arrowheads like those pictured here are still found beside streams and are unearthed when ground is tilled in the lower areas of Currinsville and Eagle Creek and even in the flower beds of houses below the bridge at Estacada. (MD.)

MOONS

by Victoria Howard

Nútx̣it gúgayλ wakáyim.
Nuǧagímx̣,
«Aga qíqayaq wílx ayákuč alx̣akx̣áymat.
Iwád alx̣agilímačx̣ida,
aga lx̣úwit čaǧayxyámt.»
Ḱáλqí aluǧagíma.

A large moon stood.
They used to say,
"Now we are lying in the middle of the backbone of the land.
We will be going down the other way,
Now we are going toward summer."
That is what they would say.

Giyáx̣əlḱiwllx̣ł ičáx̣liw wakáyim.
Nákim,
«Náyka anútx̣ida
Kánawi dán adiqəlbáyayax̣dixa,
itḱíwax, itḱáx̣a, wačgə́ti.
Nútx̣it
Ḱúuuya dán niqə́lbayx.»
Gaqúlxam,
«Máyka imíx̣liw Giyáx̣əlḱiwllx̣ł.»

She is Going is the name of the moon.
She said,
"When I will stand
Everything will be sprouting,
 flowers, leaves, grass.
When I came
Nothing at all was growing."
They said to her,
"Your name is She Is Going."

Aga nútx̣it dáwax wakáyim, ičax̣liw Wačgə́n.
Ḱalíwi gadíqəlbayx dánmax,
 itḱíwax, wačgə́ti, itḱáx̣a.
Dámmax̣ aga díqəlpx̣ix.
Aga ḱáλqí aqúpgnaya Wačgə́n.

Now this moon stood, her name is Little Shoulder.
Then indeed everything was growing,
 flowers, grass, leaves.
Everything now is growing.
Now that is what they named her, Little Shoulder.

Galútx̣it agúnax̣ wakáyim, ičax̣liw lčálamayxn.
Nútx̣it aga wílamayxn idyáḱax̣a gatx̣ílux̣.
Aga ḱáλqí ičáx̣liw.
Ḱáλqí nuǧagímx̣.

Another moon stood, her name is Her Cottonwood.
She came then as the leaves of the cottonwood came out.
Then that is what her name was.
That is what they used to say.

Moons. According to the *International Journal of American Linguistics*, "Victoria Howard (1870–1930), wife of Eustace Howard of West Linn, Oregon, lived in the ancestral region of the Clackamas and was a native speaker of the Clackamas dialect of the Chinook. Shortly before her death, during the summers of 1929 and 1930, she narrated and translated one hundred and fifty Clackamas myths, songs, poems, stories, and jokes for University of Washington Professor Melville Jacobs. Dr. Jacobs edited and published his transcriptions of these narratives as Clackamas-Chinook Texts, Parts I and II, in the *International Journal of American Linguistics* in 1958 and 1959. This text is set in Syntax phonetic, a typeface for Native American languages." (BM.)

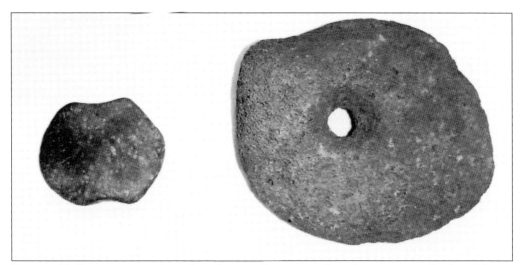

SINKERS. Different stone tools, each with a specific purpose, have been uncovered at local Native American campsites. Fishnets were used to harvest salmon, sturgeon, lamprey, and trout, all of which were abundant. A fisherman could easily net 20 large fish in one hour. These carved rocks acted as sinkers to hold the nets under water. (JR.)

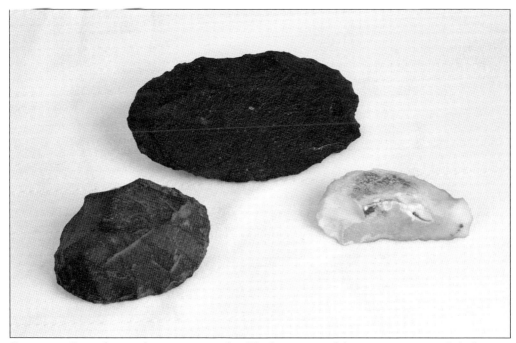

SCRAPERS. Deer shot with arrows were the Clackamas people's primary source of clothing. Fur was scraped off the hide with these sharpened stones and then sewn into clothing. Tops, leggings, and skirts were all made from deerskins. The natives also made moccasins, but these were only worn when they traveled. (MD.)

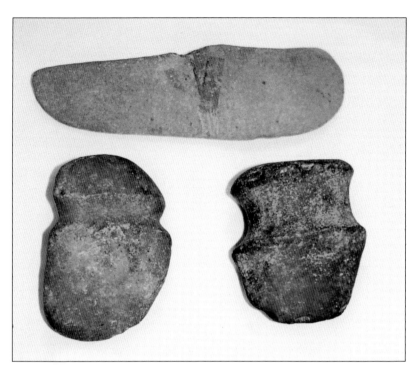

WEAPONS. A stone could be shaped into an ax or tomahawk. War clubs, or tomahawks, were used in hand-to-hand combat or thrown at the enemy. The notched stones were attached to the wooden handle by thongs. When bound to a handle, the three items shown here would serve as an ax or tomahawk. (JR.)

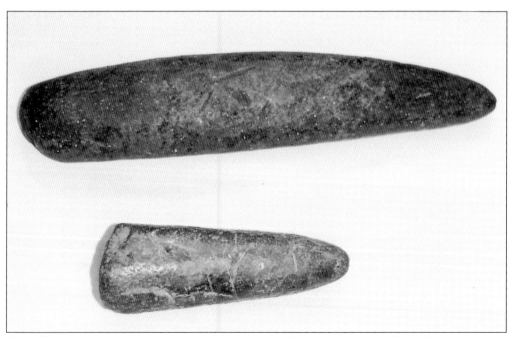

FOOD. The Clackamas dried and stored most of the food they gathered or killed. Nuts, leaves, and roots formed a basic diet. Rocks that fit the hand and had a pointed end were used for digging up plants and roots. (JR.)

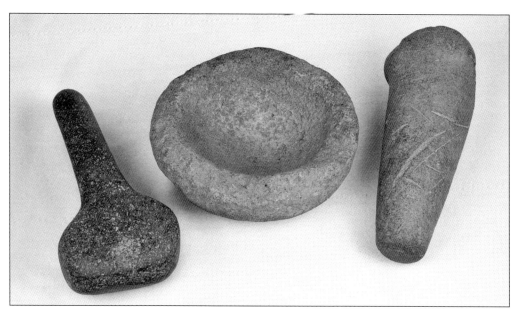

MORTAR AND PESTLE AND GRINDER. Mortar and pestles could mash bulbs, roots, and seeds. Pulverized bark from the chittum tree was made into a tea for irregularity Blue camas was a staple; the flower was steamed and the bulb was dried and powdered into flour. Oregon grapes and berries were plentiful in summer, but the huckleberry was the most sought-after. The natives regularly burned the forest on Squaw Mountain, creating an ideal habitat for huckleberries, which grow on clear ground where freezes occur. The natives, and later, settlers, camped on the mountain for weeks at a time to gather the huckleberries. The food preparation aid below consists of two parts. The large piece is a grinding slab or platform. Books on Native American artifacts call this by the Spanish word, "metate." The "mano," or hand-held, is a smaller rock that was moved back and forth or in a circular motion on the surface to grind grain and seeds into flour. (Above, JR; below, MD.)

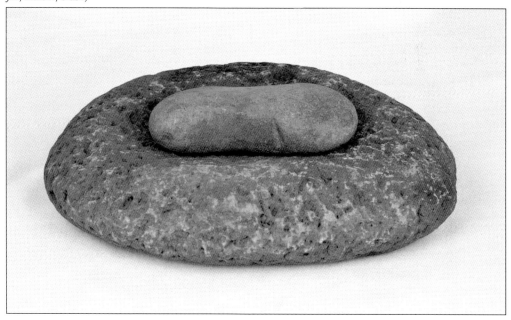

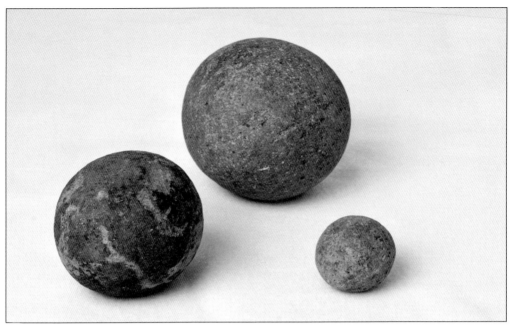

GAMES. Everyone needs occasional entertainment, and the Clackamas were no exception. Games, including gambling with bones or playing with stone balls like those pictured here, were favorites. Games of chance are risky, and legend stated that "the ultimate loss was gambling oneself into slavery." Taking and enslaving captives was common among the tribes. (MD.)

ARTIFACTS. Campsites have been identified all along the Clackamas River and on its tributaries up Squaw Mountain. Estacada resident Jack Reynolds, a collector of Native American artifacts since he was six years old, gives presentations on the history of the Clackamas featuring his impressive display of the items they used. All of the arrowheads and stones pictured in this chapter are part of his collection. (MD.)

Two

SETTLING IN

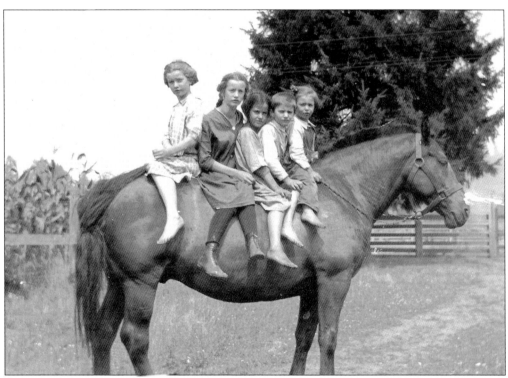

HORSING AROUND, 1916. Ted the horse patiently allowed all five Ferrel children to sit on his back for a picture at the farm in Barton. The children are, from left to right, Maude (age 12), Grace (age 14, and the only one wearing boots), Edith (age 10), Bill (age 11), and Hugh (age 7). Ted pulled the buckboard when the children's father drove to Gibson's store to pick up mail. (RL.)

Philip Foster Farm, 1917. In 1847, Philip Foster, an energetic entrepreneur, took out a donation land claim of 640 acres near Eagle Creek. His farm, a source of food and supplies at the first stop on the Barlow toll road, was a welcome sight to pioneers needing to rest and recuperate after the 2,000-mile trek from Missouri. Philip Foster Farm is now preserved as a national historic site. (JZH.)

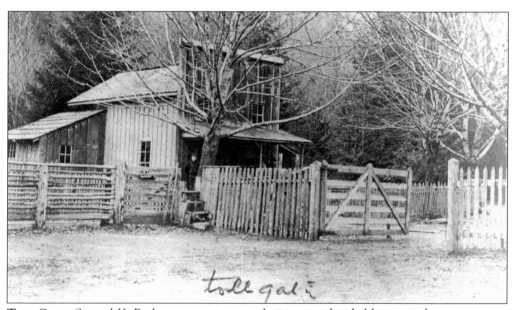

Toll Gate. Samuel K. Barlow, an engineer and visionary, decided he wanted to construct a road for wagons so immigrants would have a safer route than the treacherous Columbia Gorge. Barlow and Philip Foster formed a partnership to build a toll road around Mount Hood, referred to as "the Barlow Trail." (JZH.)

PROUD GRANDMOTHER, 1909. Jane Bradley (seated at right) came over the Oregon Trail in 1867 and married Egbert Foster, the youngest son of Philip and Mary Foster. Their home was the site of the Philip Foster Farm. Jane and Egbert Foster's daughter, Pearl (standing), married E.L. "Roy" Meyers (seated at left and holding son Egbert). Roy was a station agent for the railroad and later became a lobbyist for it. (JZH.)

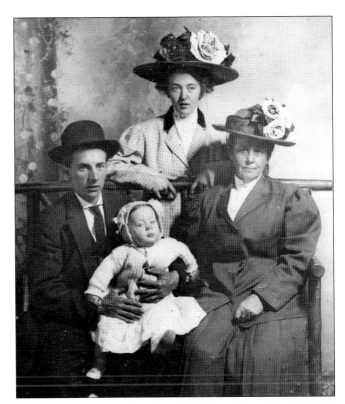

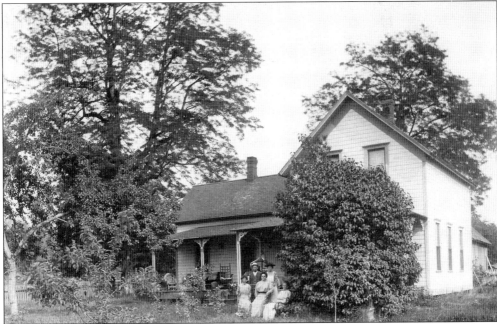

FARM HOUSE, 1910. Egbert Foster built this house in 1883. Philip's wife, Mary Charlotte, planted the lilac tree from a slip of a plant she brought from Maine. Now 150 years old, it is the oldest lilac in Oregon. Pictured here are, from left to right, (first row) Della Glover, Addie Burnett, and Jane Foster; (second row) E.N. Foster and either Pearl Foster or Foster cousin Mary Kennedy. (JZH.)

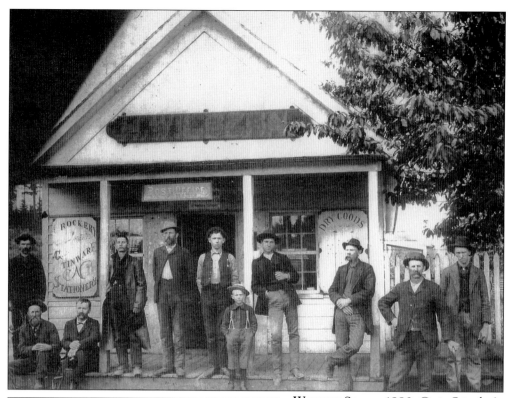

WILBERN STORE, 1880. Craig Stingley's Saloon was down the road from here and across from the Presbyterian church. Gus Burnett stands at far left. Standing on the porch and leaning against the left post is Joe Suter. Joe's brother Jim, a carpenter, made Philip Foster's coffin. Leaning against the far right post, with legs crossed, is Henry Heiple, followed by Adolph "Doll" Wilcox, and Fred Wilbern. All other men are unidentified. (JZH.)

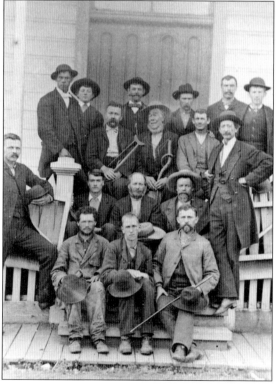

WILBERN HALL, 1885. Community meetings and parties were held in this building. Families drove here via horse and buggy to dance all night and hold basket socials at midnight. Since they could not negotiate the muddy roads in the dark, they would doze while they waited until dawn. The entry on the back of this photograph reads, "Male Population." (JZH.)

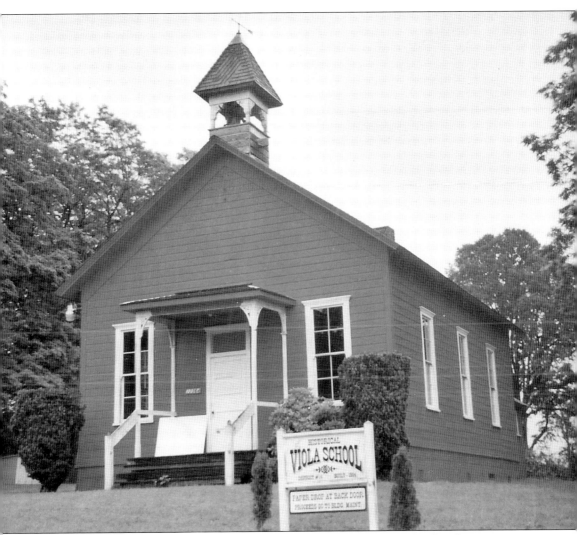

VIOLA SCHOOL. This tiny one-room school has been the most prominent landmark in town since it was built in 1894. Viola, named for an early pioneer whose last name has been lost to history, began as a fur-trading post. Abundant beaver and other fur-bearing animals were found along Clear Creek, Eagle Creek, and the Clackamas River; Hudson Bay Company established a trading post here about 1846, the same time Oregon City was settled. Soon after, settlers began arriving in Viola via the Barlow Trail and, beginning in 1850, took up donation land claims. Viola quickly became a center for business and socializing, with a gristmill, gymnasium, Masonic lodge, Grange hall, post office, church, school, and store. There was also a doctor, a blacksmith, and a magistrate. A stage line came through every week on its way to Silverton. (LF.)

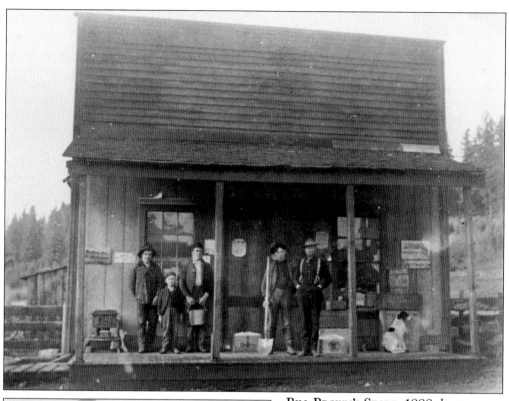

BILL BROWN'S STORE, 1888. It was packed full of goods, with exciting items hanging from the ceiling. The store had mainly good smells, a warm, glowing fire in the old stove, and home-spun character. This was a center for trading into the 1940s. Pictured here are, from left to right, Oscar Stuckey, Oliver Gerber, Sam Gerber, Maurice Ward, Bill Brown, and Maurice Ward's dog, Sport. (DCF.)

CHURCH 1888. On December 11, 1869, Asa Stone and his wife, Ann, and Abel Mattoon and his wife, Sarah, deeded land for a Methodist Episcopal church, meetinghouse, and a parsonage. People came from Garfield, Springwater, and even Salem, and would spend a week or more visiting and having revival camp meetings. In 1888, the building was taken apart and reassembled on land donated by Charles Miller. (DCF.)

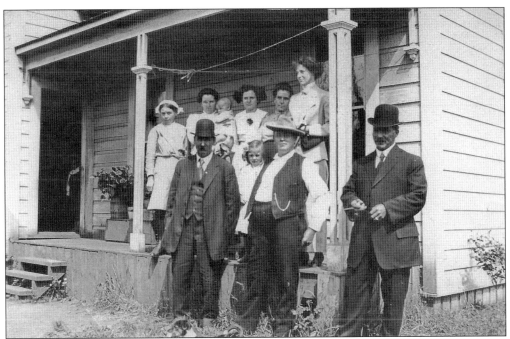

PROVED UP. In 1852, brothers Branch and Daniel Woodson Tucker each took out a donation land claim of 160 acres in Springwater. They built a cabin straddling the line between their parcels and proved that they could live on the land for the required three years. Branch's farm, granted "century farm" status in 1952, is still in the possession of the family. The above picture was taken on the front porch of the farmhouse, which still stands. William Woodson Tucker is in the center front. Immediately behind him is his wife, Laura. The Tucker farm is pictured below. (Both, NT.)

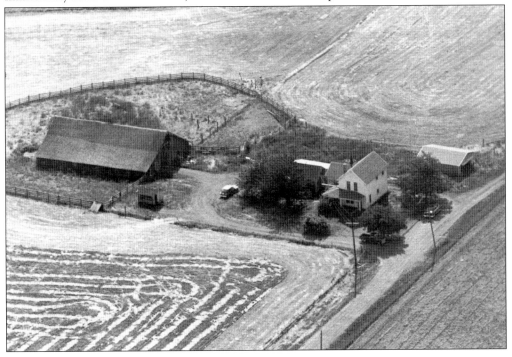

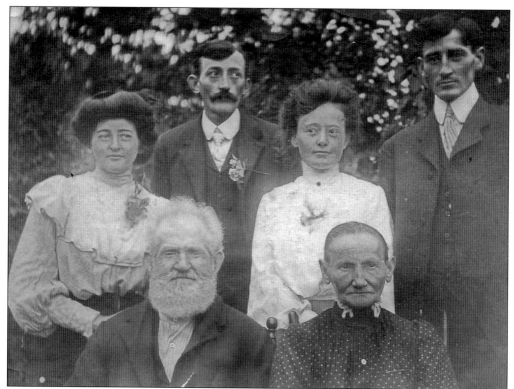

THE ENGLISH, 1904. Christopher H. Guttridge, born in Birmingham, England, in 1829, sailed to New York in 1853. He married Mary Ellen Stephenson. In 1873, they settled in Springwater. Here, Christopher and Mary Ellen (first row) are pictured with the four youngest of 10 children. They are, from left to right, Della, Joseph, Alice, and Robert. (WSG.)

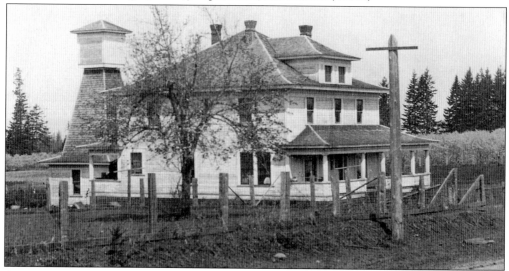

GUTTRIDGE HOME, 1915. Built before 1870, the Guttridge house stood on 161 acres that Christopher Guttridge purchased from Jacob Kandle. The other children left the area, but Joseph I., Christopher and Mary's seventh son, stayed on what eventually became a century farm. Christopher Guttridge planted the first commercial prune orchard in Clackamas County. (WSG.)

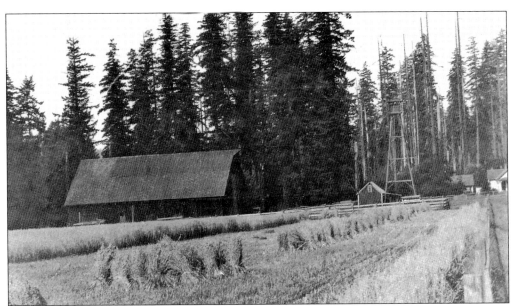

SHIBLEY CENTURY FARM, 1920. The Shibley farm, pictured above, dates back to the first land purchases in 1878, made by brothers James and Almon N. Shibley. This is the site of the first purebred Guernsey dairy in Clackamas County, started in 1918 by James A. Shibley, Almon's son. Everett, James Shibley's son, was the first farmer to bring Chewings fescue seed to Springwater. The home of James A. and Mary E. Marrs Shibley, pictured below, was built between 1880 and 1885 and still stands at the west end of Wallens Road. This picture records the effects of a 1902 fire; the burned snags in the background are a testament to how fortunate it was that the house survived. (Both, GS.)

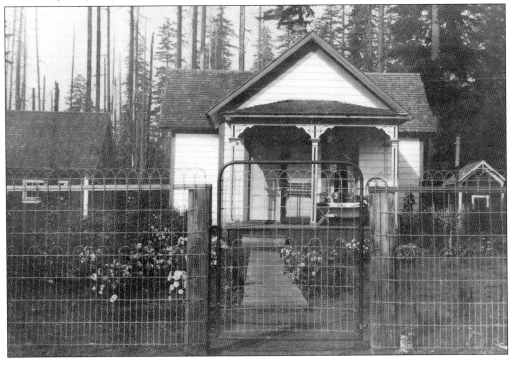

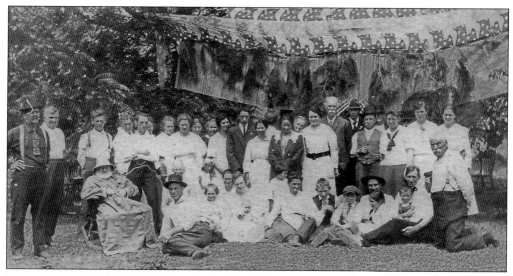

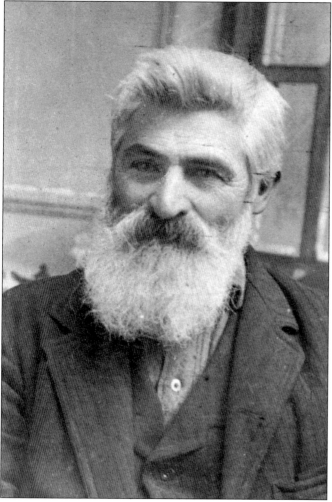

PICNIC, 1917. The photograph above was taken at one of the first Fourth of July community picnics, which the Shibley family has hosted for nearly a century. For most of those years, the yearly reunion of family and all the dear friends who live, or have lived, in Springwater has taken place on the Forest Home Stock Farm. The family patriarch, Almon Shibley, is comfortably seated in the chair on the far left. Known as "Grandpap," Almon Shibley (left) was the son of Rev. Jacob Shibley. He was born in 1834 and died in Springwater in 1920. (WSG.)

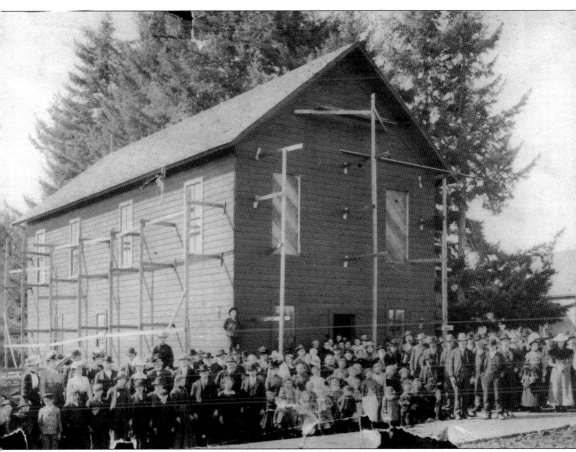

CELEBRATION. The entire population of Springwater turned out in 1899 for the dedication of the newly built Grange hall. The Grange is a nationwide fraternal organization for farmers that encourages knowledge of issues affecting rural life. The two-story building stood at the corner of Market Road No. 24 (Springwater Road) and the road to Shibley's (Wallens Road). The sash windows allowed curtains to quiver in the drafts, but the main room filled with warmth and laughter as members enjoyed regular potlucks at a long table with wooden benches. On the second level, with its big wood heater and a stage at one end, members danced and presented readings, musical numbers, plays and skits, or met for educational programs. The Springwater Grange forged a strong sense of community that still exists. The building survived the devastating fire of 1902 that swept across Springwater, but was torn down in 1949. The wood was used for the current Grange hall. In 1900, Springwater was the second largest town in Clackamas County, after Oregon City. (WSG.)

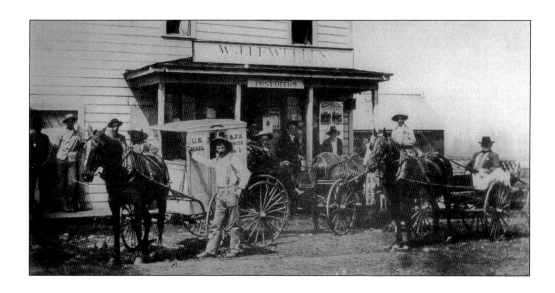

LEWELLEN STORE, 1910. In 1892, William J. Lewellen took over the store pictured above from his father, who had built it in 1852. Springwater was one of the first places in Clackamas County to have its own mail service, which began in 1874. Here, the mail cart was parked in front of the store where Mr. Moger, Wiley Howell, some of the Genseowski men, and other locals arrived hoping to receive a letter. Historically, it is known that the persons listed were present, though they are not individually identified on the photograph. Mail was addressed simply, as shown below. The person to whom the letter was written and the name of the town were all that were required. In 1910, postage for a letter was 1¢, but by 1912, the price had risen to 2¢. (Both, WSG.)

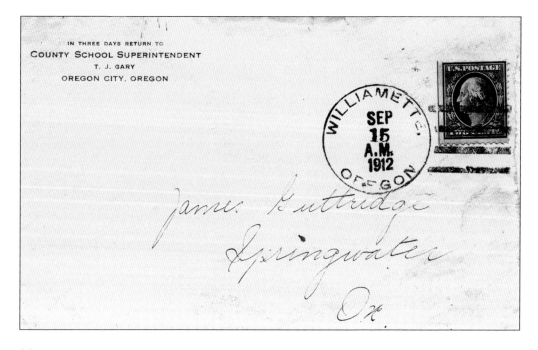

REPAIRS. The Springwater Presbyterian Church was built in 1889. It was burned in the fire of 1902 but was rebuilt across the road through generous donations and the efforts of the community. The new church was dedicated in 1904. In the early days, a workman climbed up the steeple on a ladder to install new shingles. In the 1980s, with assistance from a large crane, the steeple was removed for shingle repairs. (WSG.)

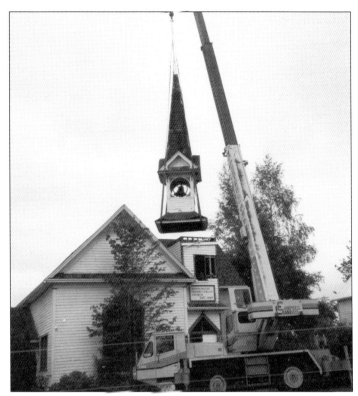

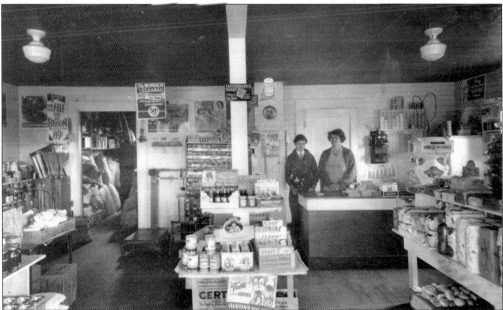

GRAND OPENING. When William J. Lewellen's store burned down around 1932, Forrest and Lois Erickson bought the property. Forrest and his father, Peter, erected a new building, which opened on Saturday, March 30, 1934. Red and White stores were independently owned but primarily sold the company's brand of canned goods. Children with a nickel could buy three pencils, a licorice pipe, and a little red sugar spot. (SS.)

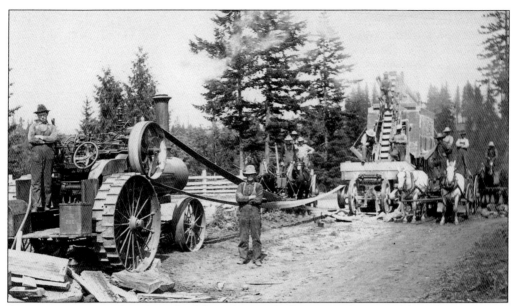

GRAVEL TAXES. Rural roads evolved from dirt to planks to gravel. A portable rock crusher was moved to locations with an abundance of field rock—meaning just about any place in Springwater. Farmers united as employees of Clackamas County to feed the crusher and lay the gravel on the road. They worked about two weeks per year, earning enough to pay their property taxes. (WSG.)

ROCKING. Most of the fields around Estacada were filled with so many boulders that farmers joked about having nothing but rock gardens. Such was not the case in the town of George, where people had to go to the rock quarry, located below the Kowall place on Robert Miller Road. (MF.)

MAIN ROAD, 1905. The winding, one-lane Estacada Road began at the Clackamas River, traversed Dubois Creek, then rose to the top of Springwater Hill where it ended at Market Road No. 24. In this photograph, Mae Kellendonk is driving her $100 Studebaker buggy pulled by her horse Old Doll. Mae routinely traveled the road on her way from Currinsville to Viola. Mae died in 1995 at age 107. (JR.)

HAYDEN FAMILY, JULY 4, 1888. Civil War Army veteran James Morton Hayden brought his family from Missouri to settle in Springwater. The road bearing his name now runs up the hill from Highway 213 to Springwater Road. Pictured here are, from left to right, James, Albert, Minnie, William, Emma Blanche, George, and Elsie Wooster Hayden. (DG.)

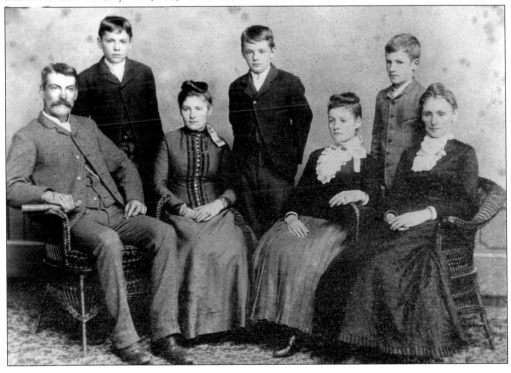

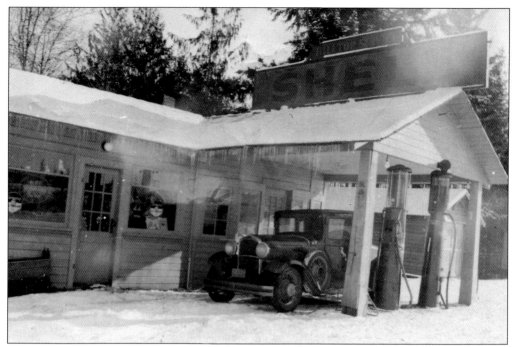

HILL TOP, DECEMBER 1949. Elsie and Everett Kiggins owned a service station and a combination tavern and convenience store at the top of the hill where Estacada Road met Market Road No. 24. After Highway 211 opened in 1958, travelers bypassed Estacada Road in favor of the easier route from Estacada to Springwater. The decrease in traffic led to the demise of the Hill Top. (JR.)

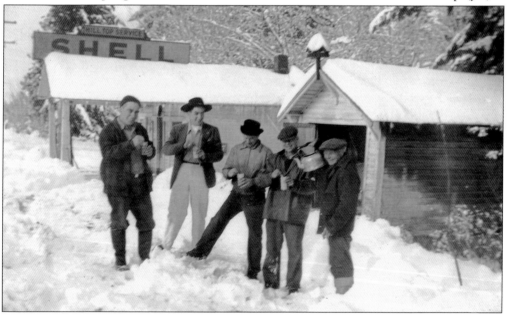

TRAVELER'S DELIGHT. Elsie Kiggins sold soda pop, cigarettes, party snacks, and her famous doubledecker ice cream cones, which only cost 5¢. After Prohibition was repealed in 1932, Kiggins served draft beer. Here, friends stopped by on a snowy day. They are, from left to right, Bill Tucker, unidentified, John Kiggins, Everett Kiggins, and Gus Rehbein. (JR.)

ELY GENERAL STORE, 1910. Currinsville bears the name of the area's first landowners. Hugh and George Currin arrived at Foster's as immigrants in October 1845. With their supplies gone and their cattle almost starved, they decided to winter in the rich river bottom to the south of the Foster claim. This community became the area's trading center, a position it held until Estacada sprang up. When the Currins moved on, John Ely bought the land, and he and his wife started a dry goods mercantile. In 1920, Currinsville had a Methodist church, public school, A.E. Alspaugh Flour Mill, and blacksmith James O. Linn. John Ely, postmaster at the store, handled the daily mail. The Ely family members pictured below are, from left to right, Maurice, John Kreigh Ely (holding Glenn), Amy Louisa Wade Ely, Mary, and Gladys. (Both, CG.)

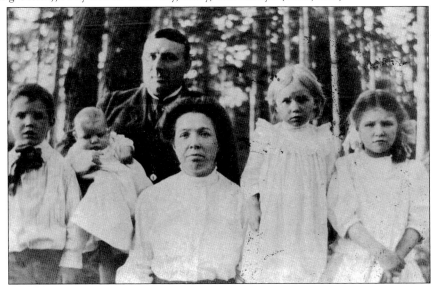

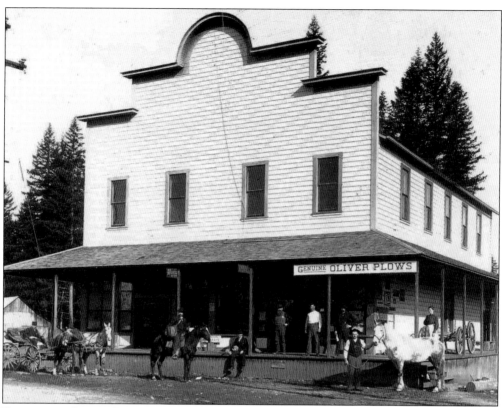

BURGHARDT STORE. In 1876, Ernest H. Burghardt settled on Deep Creek and built a gristmill and a store. In May 1896, a post office was established in his store with him as postmaster. The building pictured above was constructed later, closer to the railway. The second floor served as a meeting hall and dance floor. Burghardt's store operated until it burned to the ground in 1933. The town of Barton was actually only three miles long, with homes on both sides of the road. The hub was a short half-mile stretch between the Barton stores and the school. The railway line coming from Estacada (pictured below) crossed the road at another Barton store built by Halley F. Gibson, seen at left in the photograph. The track curved to the right and onto a series of wooden trestles that took it to Gresham and into Portland. (Both, MF.)

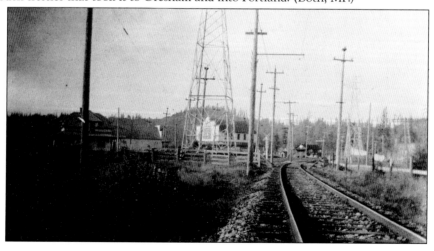

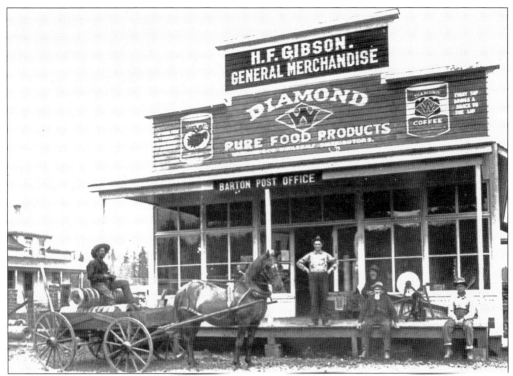

BARTON STORE, 1911. The store sold food, fabric, fuel, and everything in between. Residents bought supplies, picked up mail, and stayed to "chew the fat" with neighbors. In the image above, William P. Ferrel, in a wagon pulled by his horse Ted, was greeted by, from left to right, general merchandiser Halley F. Gibson, postmaster J.D Morris, and residents A.W. Alspaugh and C.A. Burghardt. Gibson's house, which still stands, is visible to the left of the store. The Gibson siblings pictured below are, from left to right, Richard, Nora Gibson Reid, Cora Gibson Udell, Halley, James (father), Henan, and Harvey. (Above, MF; below, KE.)

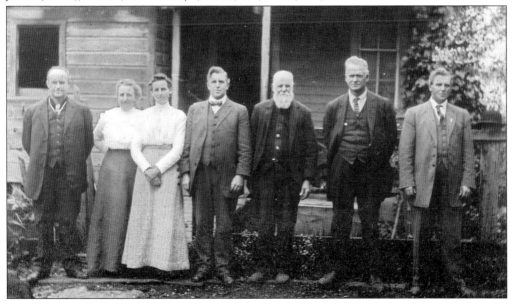

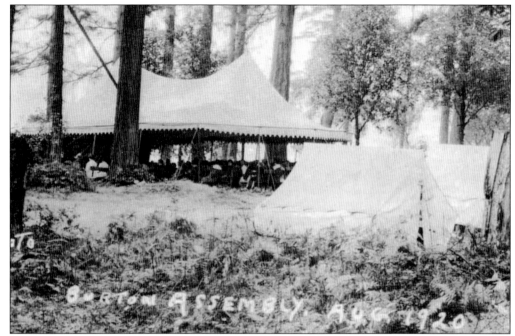

BARTON BAPTIST ASSEMBLY, AUGUST 1920. Weeklong tent revival meetings and encampments were common religious experiences from the late 1800s to the 1930s. Attendees pitched their own tents on the grounds and ladies prepared picnic lunches. Fiery preachers mesmerized the groups and, in the case of the Baptists, performed baptisms of the faithful in the nearby Clackamas River. (MF.)

MUSIC, 1950. The Viola Church pastor's wife, Maxine Reno, was a chorister who worked with the local children, teaching them how to sing. Hearing the choir was described as heavenly. From left to right are Terry Tracy, three unidentified, Lea Hodgkiss, Arlene Hodgkiss, Jim Weston, unidentified, Gary Fouts, Jim Fouts, Ted Hodgkiss, and Mrs. Reno. (TT.)

CIVIL WAR. Henry Benton Sarver, born in 1846, enlisted in the Confederate Army Virginia Volunteers when he was 18. Once the conflict ended, he walked across America with an early wagon train. He homesteaded land near Fanton Guard Station, 14 miles southeast of Estacada. Sarver died on December 10, 1935. (RL.)

PONY EXPRESS STOPPED HERE, 1904. The family of John Peter Irvin is pictured in front of the house he built before the start of the 1900s. The main floor was a mercantile and the first post office in Garfield. Mail was originally delivered by a man on horseback. John is seated at far left, and his wife, Mary Katie, is seated at right. (JE.)

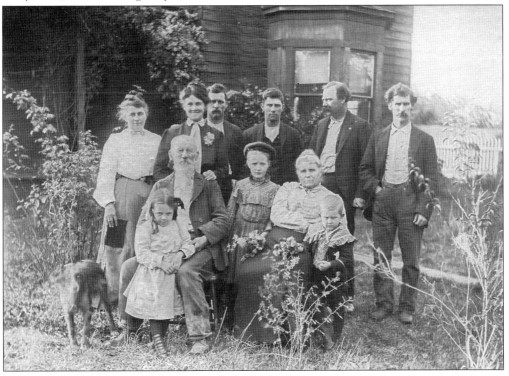

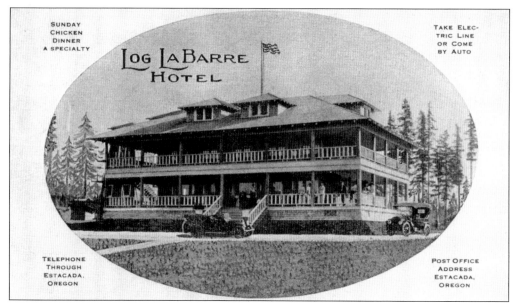

LOG LABARRE HOTEL, JUNE 1915. Visitors to Estacada could drive to this beautiful 120-acre fishing and hunting resort in upper Garfield. The lodge, made of mammoth logs, had cozy rooms and hot and cold water in the bathrooms. Residents still talk about the hotel, but, sadly, it burned to the ground in the LaDee fire of August 1929. (SB.)

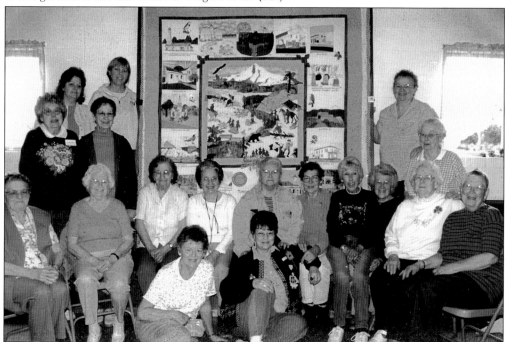

SKIP-A-WEEK QUILT CLUB. Meeting in the Garfield Grange, this group of women continues a tradition started in 1921. Dedicated to the community, this quilt club may be the oldest in Oregon. The group donates quilts to the Estacada Fire Department, for people who have lost their homes to fires, and to charitable organizations. Behind the ladies is their quilt depicting Estacada's history. (RL.)

Three

ABC

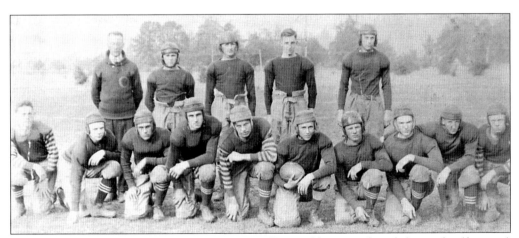

ESTACADA HIGH SCHOOL FOOTBALL TEAM, 1917. Pictured here are, from left to right, (first row) Joel Bowman, Ray Lovelace, Ernie Smith, Ray Heiple, Ivor Coop, Frank Somer, Virgil Douglass, Walt Smith, Doug Drill, and ? Hill; (second row) coach ? Rathford, Oral Stormer, captain Otto Jannsen, Ray Drill, and Homer Sarver. A Stormer descendant says the team must have been desperate for players, because Oral was a small guy for this game. (SB.)

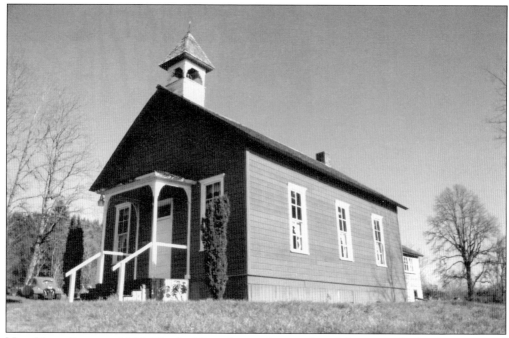

NEW VIOLA SCHOOL, 1894. The building shown above replaced the original school constructed in 1846, the year Viola was settled. The new school boasted a small pump organ in the corner and a horse stable near the two "his" and "hers" outhouses. The photograph below was taken in the front yard of the first schoolhouse. Teacher Charles Rutherford is pictured at left, with students including Bert Rogers, Myra LaCroy, Ervan LaCroy, John Mattoon, Sammy Gerber, Emily Jubb, Herb Rogers, Maurice Ward, Robert Wooden, Jim Rutherford, Lulu Miller, Joe LaCroy, Willie Heater, George Rogers, Howard Hayden, John Rogers, Anita Jubb, Loretta Eaken, Lizzy Zurcher, Katie Zurcher, Fred Zurcher, Ray Miller, Smith LaCroy, Bert Mattoon, Jenny Jubb, Mary Hamilton, Eva Mattoon, Cora Ward, Everett Wooden, Urania LaCroy, Margaret Zurcher, Mary Zurcher, Christina Hamilton, Carl Ward, Florence Jubb, Viola Eaken, and Louis Gerber. (Above, DG; below, DCF.)

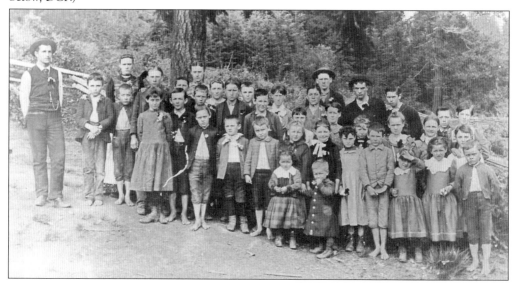

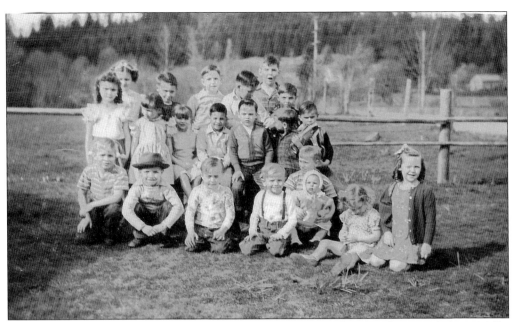

VIOLA SCHOOL CLASS, 1940s. Only a few students are identified in this photograph: Jerry Melke is third from left and Terry Tracy is fourth from left in the first row; Jim Fouts is fourth from left and Dale ? is fifth from left in the second row; Gary Fouts is third from left and Jim Weston is fourth from left in the third row. (TT.)

EAGLE CREEK SCHOOL. In 1848, five families—with a total of 17 children—hired Rebecca Denny to teach in their community. A building erected in 1850 was replaced by a new two-room school in 1893. The building shown here was constructed in 1912, added to in 1930, and later remodeled to form five classrooms. Eagle Creek School District No. 17 consolidated with Estacada School District No. 108 in 1969. (JZH.)

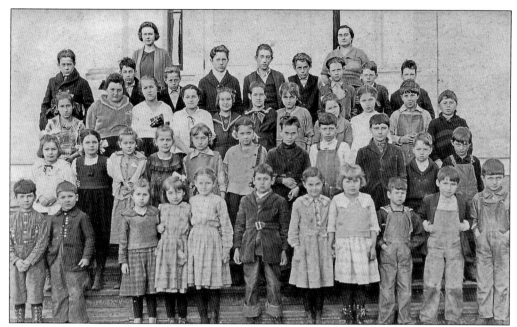

EAGLE CREEK SCHOOL, C. 1920. By comparison with Viola, the community of Eagle Creek had over three times the number of students. Forty-two children enrolled at the school gathered on the front steps for this photograph. Teacher Lillian Still, standing at far left behind the fourth row, is the only person identified in this photograph. (JZH.)

GRADUATES, 1951. This is the graduation photograph for the eight students who completed their schooling at Eagle Creek Elementary. In 1952 they, like others from outlying areas, would soon begin making the trip to Estacada Union High School for classes. (JZH.)

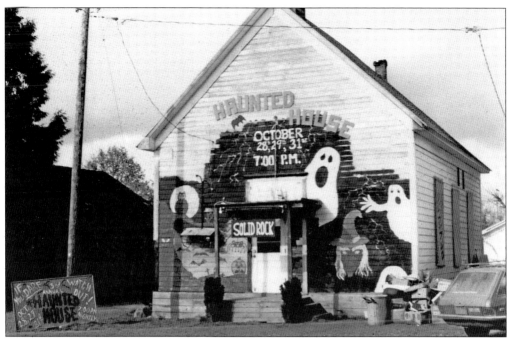

ORIGINAL ESTACADA SCHOOL. This building, on First and Main Streets, was reportedly used as a school before the construction of the Estacada Grade School. It was turned into a haunted house for Halloween shortly before it was torn down in the 1970s. (JH.)

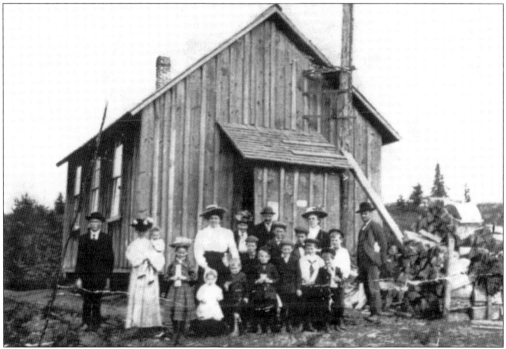

FIRST SCHOOL IN PORTER, 1906. The families of Joel B. Bowman, Mrs.? Fisher, Guy Hunt, and Charlton Snyder celebrated the building of their school by posing in front of the brand-new building. These were the first families to settle in the town of Porter. (SB.)

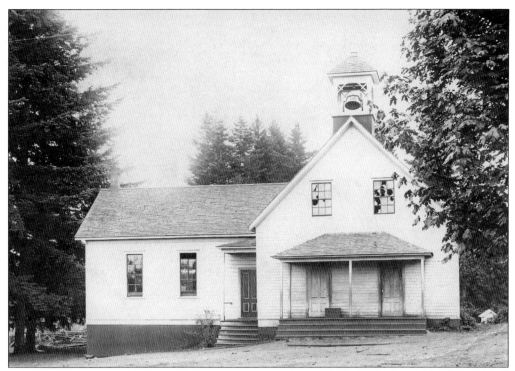

SPRINGWATER SCHOOL BUILDING. The big room at right held the fifth through eighth grades, while the "little room" held first through fourth grades. Stoves inside the classrooms heated most rural schools, but instead of a stove, a wood furnace underneath the little room heated this school. (WSG.)

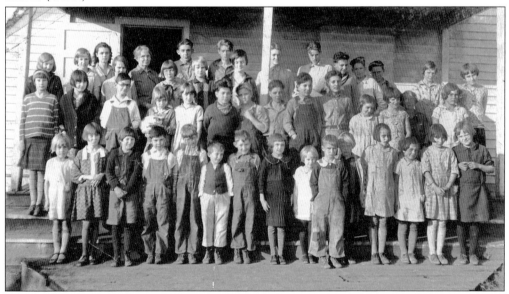

SPRINGWATER CLASSES IN 1929. This school always had two classrooms. One teacher taught grades one through four, while the other taught grades five through eight. From the look of this picture, the teachers had their hands full this year. Teachers Ruth Carey and Jessie Hesser are third and fourth from the left in the fourth row. (WSG.)

GOODBYE SPRINGWATER SCHOOL, 1948. This was the last class that graduated from Springwater School before consolidation. Pictured here are, from left to right, Delmer Gant, Marge Horner, Maurine Schubert, Bill Avery, Vern Anderson, Pearl Avery, Vera Zehner, and Danny Swanson. Standing in front of the students is Mary Marrs Shibley, age 87, who attended the graduation as a special guest. Shibley received her "schooling" in this building. (WSG.)

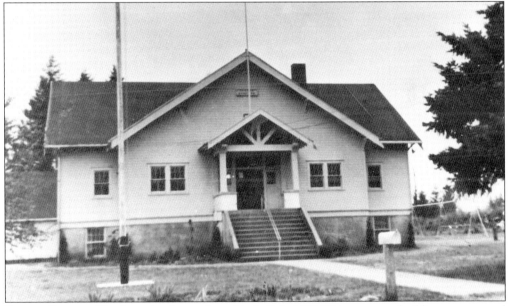

BARTON SCHOOL. The first school was a log cabin built in 1882. This two-story building, constructed in 1925, had a full basement with a wood furnace that doubled as a play area for the children. The main floor was divided into two classrooms by folding doors. As a boy, Til Forman was paid $5 per month to maintain the building. The man hired to replace him earned $50 per month. (KG.)

43

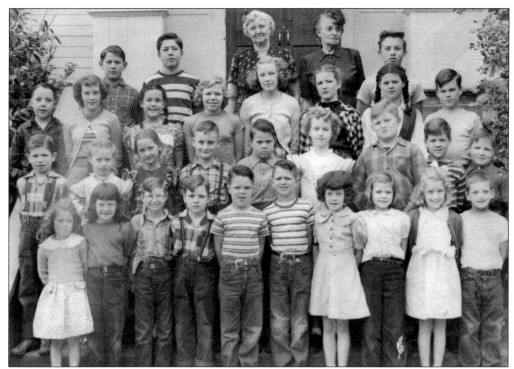

BARTON SCHOOL, 1952. Standing in front of the door, Mrs. Fitch (left) and Mrs. Fate were the teachers this year. Plans had not yet been made, but in a few years, a new school was constructed and this one was used as a community building before being torn down in 1980. (KG.)

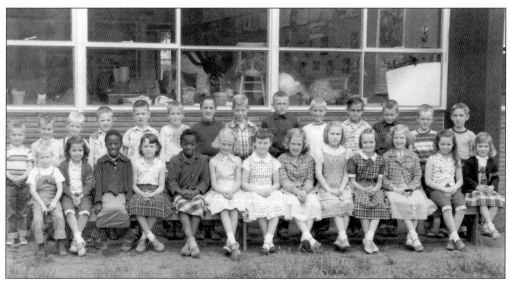

LOTS OF LIGHT, 1961. The new Barton school on one floor had large windows along one side. This class of lower grades was a large one, compared to 1948 when there were only four students in the entire school. Students learned lessons in this building until Barton consolidated with the Estacada school district in 1978. (KG.)

THE GIRLS. These are the upper-grade girls in the George school, lined up in front of the fence for a photograph taken with a Brownie camera. They obviously felt comfortable and happy in each other's company—one of the advantages of receiving education in a small school. (MF.)

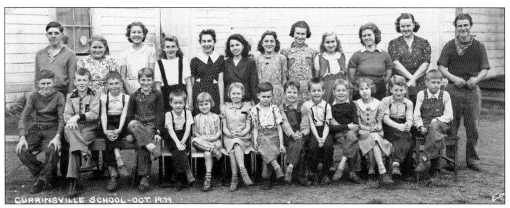

CURRINSVILLE SCHOOL, 1939. This was the last class; Currinsville consolidated with Estacada in 1940. From left to right are (first row) Junior Johns, Robert Newman, Walter McKenzie, Wilbur Courtain, Frank Reynolds, Norma Courtain, Maybel McKenzie, LeRoy Kiggins, Ed White, Robert Reynolds, Leon Hilderbrand, Ruth Reynolds, Robert Potter, and Jim Hilderbrand; (second row) Rosaleen Matthews, Dorothy Hilderbrand, Helen McKenzie, Mary Allison, unidentified, May Thompkins, Patsy Morrel, Alice Matthews, Jo Ann Moll (teacher), Mary Chambers (teacher), and Ed Larson. (RL.)

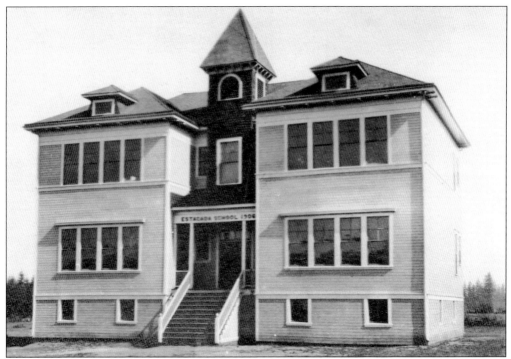

FIRST ESTACADA GRADE SCHOOL, 1906. By November 1904, the Estacada cooperative school had 38 students enrolled for the six-month term and needed a building. Al Lindsey used lumber processed in his own mill to construct this two-story school. Lower grades were taught on the first floor; upper grades attended classes on the second floor until moving to a new brick high school in 1917. (NT.)

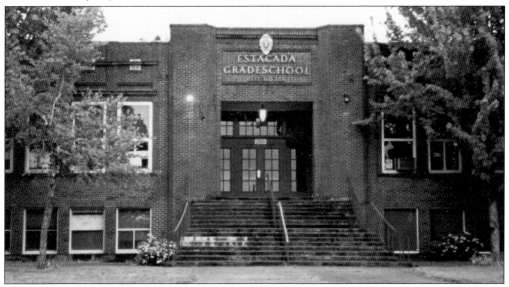

ESTACADA SCHOOL UPGRADE, 1932. The wooden two-story grade school built in 1906 was showing its age, so a new brick grade school was constricted on upper Main Street. This was during the Depression. The brick masons were paid 75¢ an hour. The sturdy building they erected lasted for over 70 years, until it was replaced. (NT.)

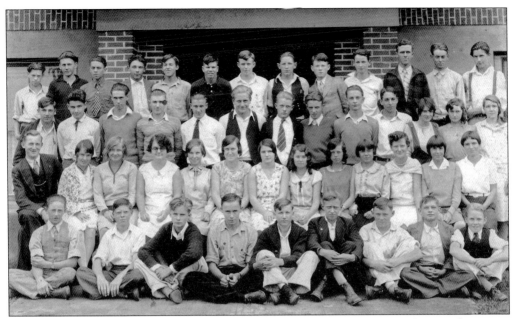

ESTACADA HIGH SCHOOL FRESHMEN CLASS OF 1931. Bright-eyed and eager, these students were rising to the exalted status of upper class men and women. They had wonderful opportunities in front of them; not only were they moving up in rank, they were moving to a brand-new building. (BH.)

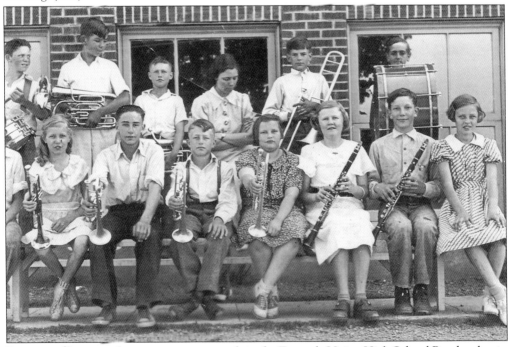

PRACTICE. Young students preparing to march in the Estacada Union High School Band gather in front of the school. They wear regular school clothes, but even if they had uniforms, girls always wore skirts while boys dressed in long pants. The unidentified music teacher in the center of the second row does not appear thrilled with their recent rehearsal. (JZH.)

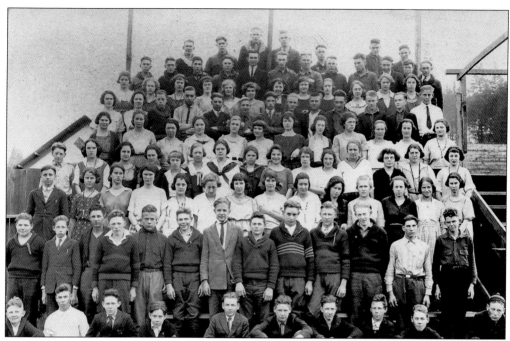

SENIOR CLASS, 1935. The strong and sturdy bleachers at Estacada High School were built to hold active sports fans. It was a good thing, too, since they hold over 100 graduating men and women in this photograph, which was taken on what appears to be a typical Estacada misty morning. (MF.)

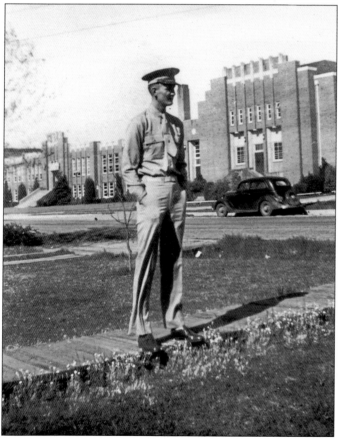

REMINISCING. Even during the Great Depression, education was of prime importance, so Estacada High School—the beautiful, modern, well-equipped, state-of-the art building seen in the background—was constructed in 1936. Graduate Glen Wolcott, pictured after his return from service in the US Army during World War II, is happy to be back in his hometown. (GW.)

Four

WE HAVE POWER

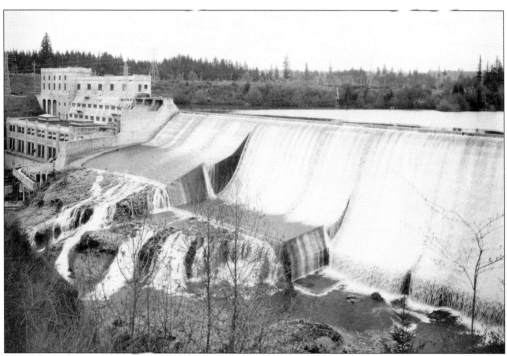

RIVER MILL DAM. Imagine the task of harnessing the frothing water-horse called the Clackamas River, taming its freedom-loving nature into the placid, calm-tempered lake shown here, and then loosing the pent-up energy to rush down the penstocks, turning the massive wheels of the turbines in order to generate electric power. (PGE.)

A DAM SITE. In response to Portland's increasing demands for electricity, Oregon Water Power Railroad Company (OWPRC) found an ideal spot on the Clackamas River. Morris Brothers Investment Bankers supported the concept of construction of a dam and hydroelectric facility and built a railroad line to the dam site, known as Cazadero, seen here on the left. The construction workers' camp had 60 houses on one narrow street. (WSG.)

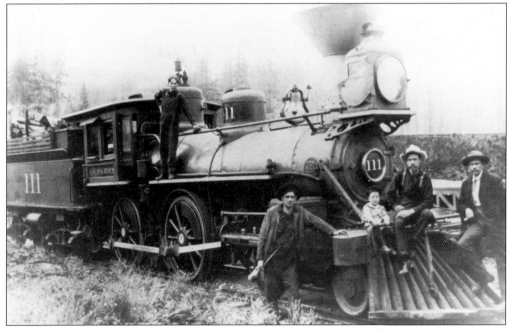

GOOD OLD NO. 111, 1902. This was the first engine to operate on the Oregon Water Power Line, built to carry supplies to construct the Cazadero Dam and Faraday Powerhouse. Pictured here are, from left to right, unidentified, engineer Bert Lowe (with oil can), unidentified, fireman E.L. Meyer (sitting on cattle guard), and conductor Harry Kinney. The engine was purchased from Union Pacific. (JZH.)

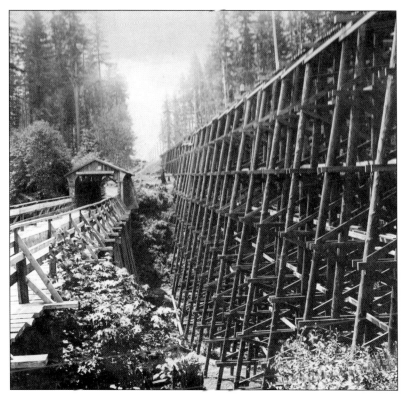

EAGLE CREEK BRIDGE, 1904. This railroad bridge was 110 feet across. A sign over the entrance to the covered bridge on the road at left read, "$25 fine for riding or driving faster than a walk across this bridge." This photograph was signed "E.L. Meyers Freight and Passenger Agent, OWPRR Co. Estacada, Oregon. June 11th '04." The initials stood for Oregon Water Power Railroad Company. (JZH.)

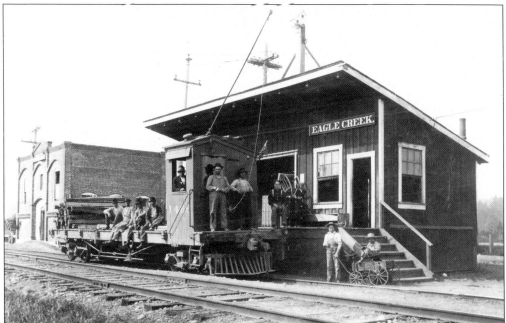

DEPOT. Numerous stops, or stations, were built along the tracks. Once the train reached Cazadero it was greeted by the station master at a depot like the one pictured here. The portion next to the track was built at a height equal to that of the bed of a flat car or boxcar, allowing for ease of loading and unloading and removing the need for a ramp. (JZH.)

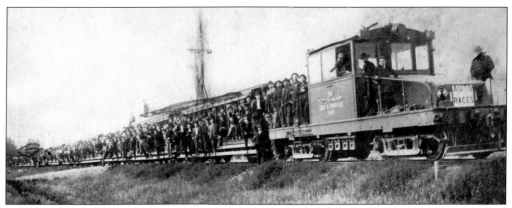

WORKERS. It took a trainload of men to build a dam, and the OWP&R Company provided trains for transportation. Construction workers rode on open flatcars from Estacada to the dam site. This train, filled to capacity with men heading for Cazadero, is so long that the end of it is not visible in the photograph. (JR.)

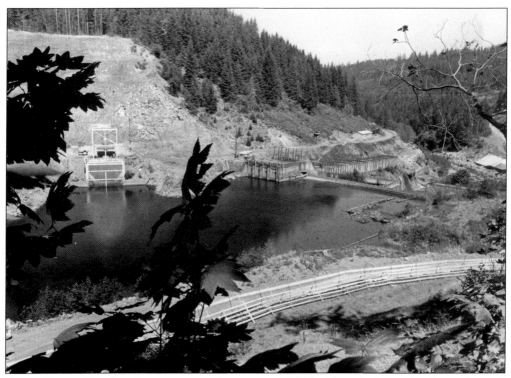

ROCKY START. Cazadero Dam was a wooden structure filled with rock. A wooden flume diverted water into Faraday Lake. Old-timers remember that the dam and flume often leaked. This photograph was taken from the upstream side of the dam. Enough water must be stored here that it can flow down through the penstocks at a rate fast enough to turn the generators. (PGE.)

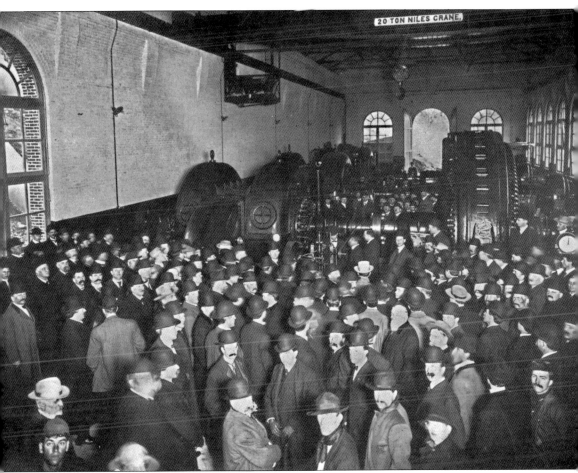

OPEN FOR BUSINESS. Faraday Powerhouse and Cazadero Dam opened amid great fanfare on February 25, 1907. Three special trains carried Oregon state and Portland city leaders, as well as influential businessmen, to the site, where they crowded into the plant for the commissioning ceremony. Following the formalities, Oregon governor George Chamberlain turned the wheel to open the flume gates, and the three immense 5,000-horsepower generators began spinning. Portland mayor Harry Lane threw the switch that sent the current over the transmission line, doubling the amount of power delivered to Portland. At that moment, the electricity illuminated a huge sign that was built atop the downtown Portland Building for the occasion. Funded by Portland Railway Light & Power Company, the plant and dam took four years to complete at an estimated cost of $1 million. The design, by noted hydroelectric engineer T.W. Sullivan, was considered revolutionary. (PGE.)

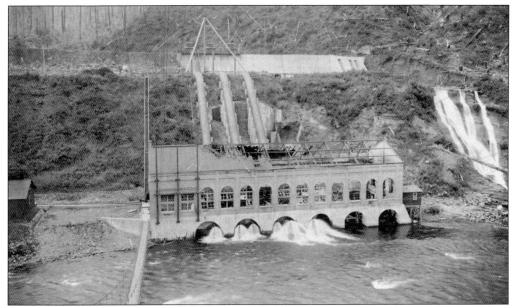

UP IN THE AIR. On June 21, 1908, only a year after its completion, the Faraday Powerhouse was damaged when one of the generators malfunctioned and blew apart. Bits of metal flew into the air and through the ceiling, leaving a big gap in the roof, destroying the plant's other generators and virtually demolishing the interior. However, by November, all was repaired and three new generators were in place. (PGE.)

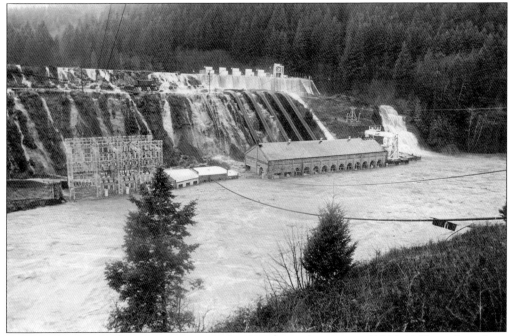

TOO MUCH WATER. There were two major flood events in the winter of 1964–1965, resulting from the rapid melting of an unusually heavy snow pack in combination with torrential rains. This photograph shows that water was as high as the bottom of the first window sash on the downriver side of Faraday Powerhouse, which contained 15 to 20 feet of water. (PGE.)

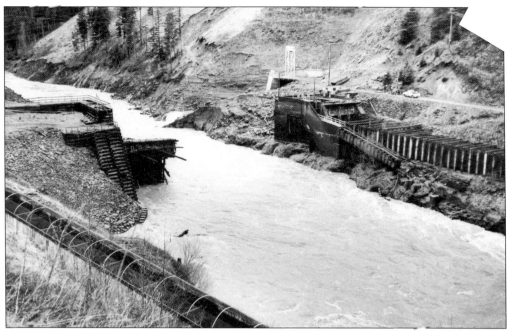

Failure. The flood of December 1964 severely damaged the 1907 timber, crib rock–filled Cazadero Dam. In a January 1965 flood, the dam failed completely. In 1966, a gated gravity dam replaced the old Cazadero dam, and the earthen embankment that impounds Faraday Lake was upgraded. The footbridge that once crossed the river, allowing employees to walk over from the highway on the opposite side, was removed. (PGE.)

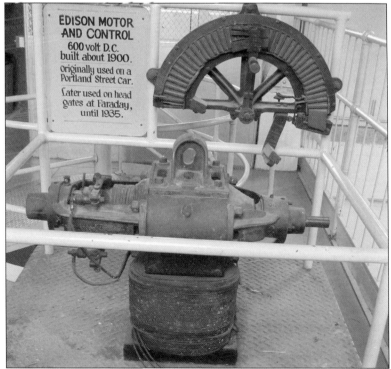

Recycled. This is an Edison 600-volt DC motor, built about 1900 and originally used on a Portland street car. It was installed in the Faraday Dam, where it was used to open and close the head gates. This motor was replaced in 1935, but is preserved as a historical artifact inside the River Mill Powerhouse. (PGE.)

EDISON MOTOR AND CONTROL
600 volt D.C.
built about 1900.
Originally used on a
Portland street car.
Later used on head
gates at Faraday,
until 1935.

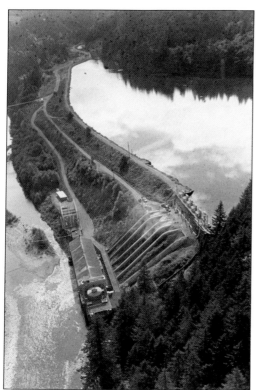

BEAUTIFUL. This aerial view of Faraday Lake (right) and the powerhouse (left) is a testament to the enormous task of harnessing the Clackamas River. The functions of all five dams are now handled from the Faraday station by computer. In case of emergency, however, personnel at the individual stations can run any of the dams and powerhouses. (PGE.)

NORTH FORK DAM. Bowing to increasing demands for power, Portland General Electric built the last of its Clackamas River facilities in 1957. This created an obstacle for fish migrating up the river, so a fish ladder (not visible in this photograph) was built that extends from below Faraday Dam and continues upriver above North Fork. With a length of 1.7 miles, PGE claims that it is the longest operating fish ladder in the world. (PGE.)

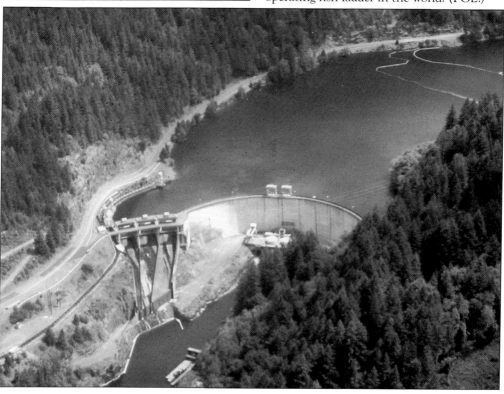

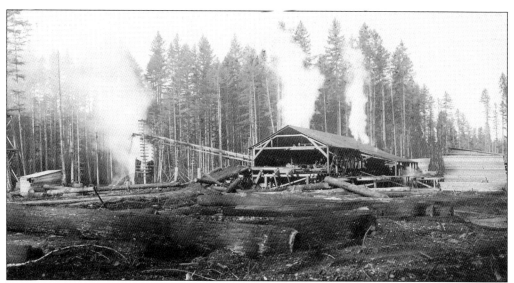

RIVER MILL. This mill was built on the Clackamas River, near the site of the new dam. Timber cut on the surrounding hills was pulled here by a donkey engine driven by a 40-horsepower steam boiler. Boards were then cut for the framework to hold the cement for the new dam. The completed construction was, naturally, called River Mill Dam. (NT.)

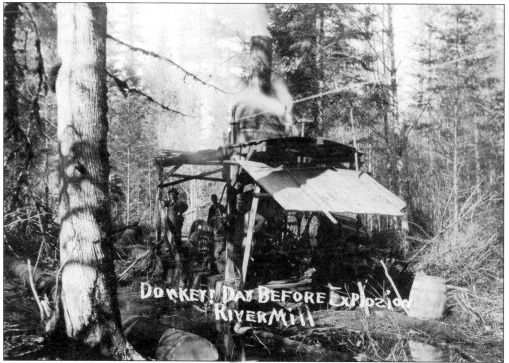

LOGGING CREW, 1911. On Saturday, March 2, eight loggers employed to fell timber for the construction of the wooden cement-holding forms for the new Clackamas River dam arrived at the job site. The morning was chilly but steam from the boiler of the donkey engine rose into the air. At 7:00 a.m., the men gathered around the boiler to warm their hands before starting work. (JR.)

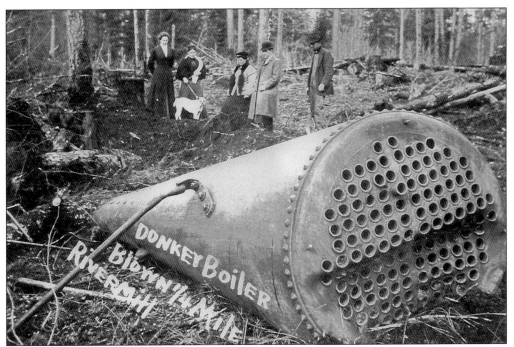

EXPLOSION. At 7:05 a.m., the heavy donkey boiler exploded. An onlooker said, "It floated through the air as if it were a man's hat driven by a gust of wind." The boiler was thrown 500 feet into the air, turning and twisting until it landed on the ground a quarter-mile away. The earth shook as the boiler plunged to a depth of six feet. Seven of the men lost their lives. (JR.)

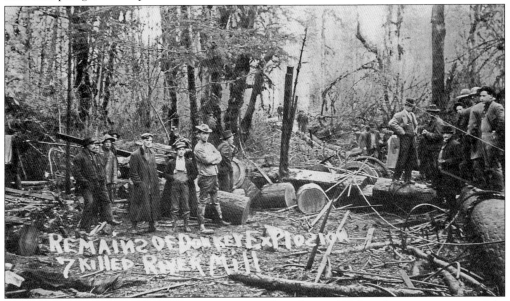

REMAINS. The men were blown distances ranging from five to 150 feet. It was a gruesome sight and a terrible loss of life. Little was left of the loggers' base of operations. Once the bodies were removed, onlookers stood around in disbelief, surveying the ground littered with broken trees and mangled machinery. Investigators determined that the accident was caused by a faulty safety valve and low water inside the boiler. (JR.)

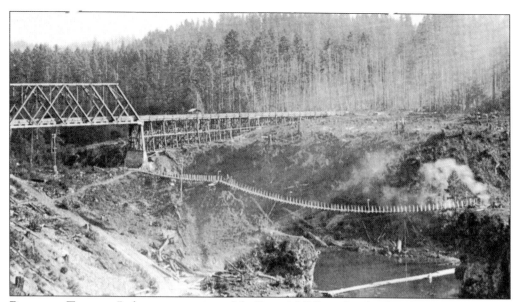

RAILROAD TRESTLE. Before construction of the River Mill Dam, Portland Railway Light & Power Company built a railway trestle on a spur of the Cazadero line. This monstrous wood-and-metal-bound bridge was 200 feet long and spanned the Clackamas River, from the Estacada side to the Springwater side. Merchants on both sides shipped goods across the bridge, which was the most direct route from one bank to the other. (JR.)

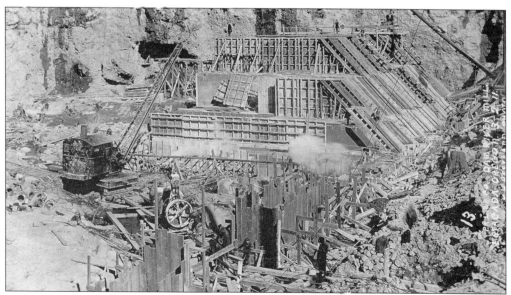

SCAFFOLDING. Logs gathered from the nearby hillsides and milled into lumber formed the base for these 100-foot high frames that eventually held 50,000 sacks of cement for the dam. This picture is from a postcard that read "Here is the photograph of part of the work at River Mill only now this place is filled with concrete. If you can, see all the stuff they had to clear away first." (JR.)

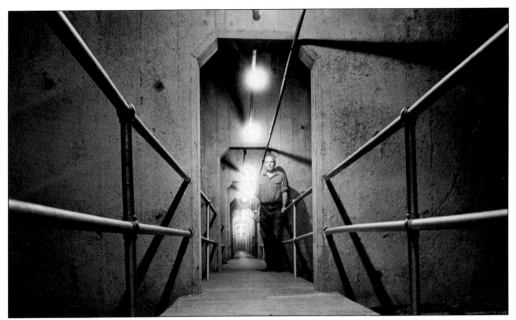

AMBURSEN. River Mill, a 936-foot long Ambursen type dam spanning the Clackamas River, is built of a series of discrete buttresses placed between 14 and 18 feet apart with hollow spaces between the buttresses seen in this photograph. The unidentified man is standing on the walkway inside the dam that travels the full width of the dam. The River Mill Dam was the first of three Ambursen projects in America built west of the Rocky Mountains. (PGE.)

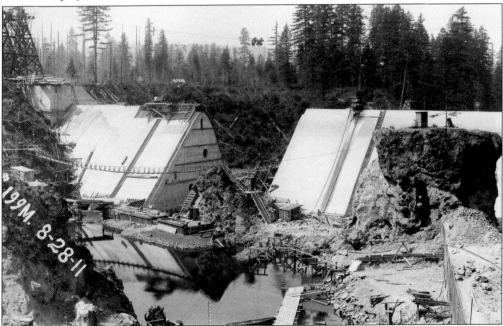

MEETING. This is a view taken from the back, or upstream, side of River Mill Dam. The two sections, or abutments, of the dam approached each other from the banks at Springwater on the left and Estacada on the right. A cofferdam diverted the river water and a suction pump was at the ready to keep the ground dry while concrete was poured. (PGE.)

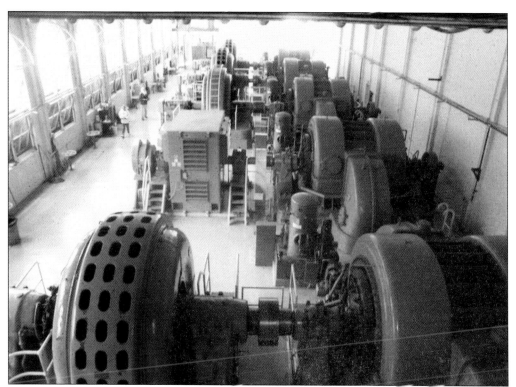

ADDITIONS. Originally, the dam had three generators. Another generator was installed in 1927 and a second in 1952 bringing the total number to five. They are fed by five penstocks, each of which is 11 feet in diameter and delivers 900 cubic feet of water per second to each turbine. Together, they generate 30,000 horsepower of electricity. If less power is needed, the gate to a penstock is closed and that generator is temporarily taken offline. (PGE.)

CLIMB. Before the dams were built on the Clackamas River, settlers said the salmon were "so thick you could walk on their backs from shore to shore." To assist fish migration around the dam, PRL&P built a concrete, water-filled fish ladder that stepped up the face of the dam in a series of right-angle turns from the river to the lake at the top. (PGE.)

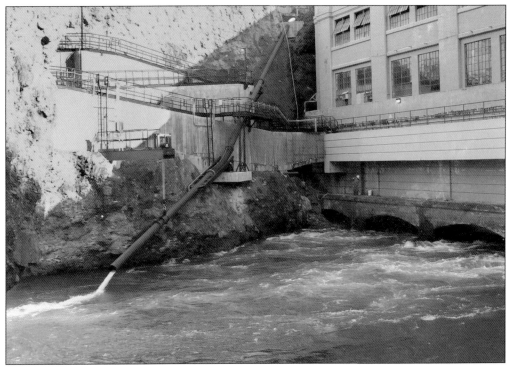

EXPRESS RIDE. Fish making the journey upriver past the dams enter the Upper Clackamas River Habitat. Young fish migrating down the Clackamas are diverted into a pipe above North Fork that carries water and fish down below River Mill Dam, where they enter the Clackamas again. The water flowing out of the express pipe is visible at left in this photograph. (PGE.)

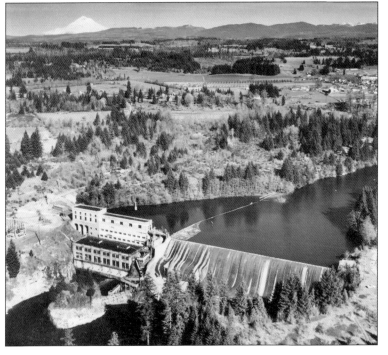

FINISHED. The River Mill Hydroelectric Project was completed ahead of schedule. At 11:00 a.m. on Tuesday, November 11, 1911, the gates of the dam were closed and Clackamas River backed up, forming a mild and placid stream where there had once been turbulent and swift-flowing waters. The backwater, named Estacada Lake, rose 80 feet, to within 20 feet of the dam's spillway and as far back as Cazadero dam. (PGE.)

COLLAPSE, JULY 11, 1918. A train equipped with two electric locomotives and two freight cars, and manned by an engineer, conductor, and two brakemen, crossed the bridge. Once the goods were loaded, the train started its return trip across the lake formed by the backwater of River Mill Dam. It was almost in the middle of the lake when disaster struck—without warning, the trestle collapsed and the engine plunged into the water. (JR.)

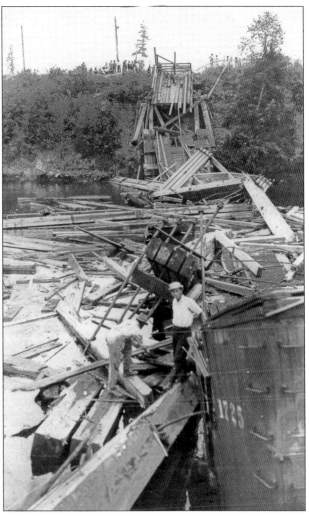

FIREMEN SURVEY THE WRECKAGE. The brakemen struggled to shore, but the conductor's body was found among the trestle timbers. Several weeks later, when the wreck was finally lifted to the surface, the engineer's body was found pinned underneath one of the locomotives. The trestle timbers, submerged in Estacada Lake, probably rotted in the water. Goods salvaged from the wreck included a case of shoes, flour, and a churn. (BC.)

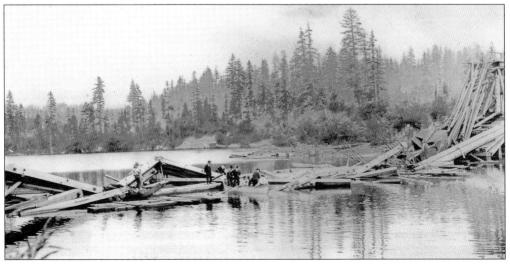

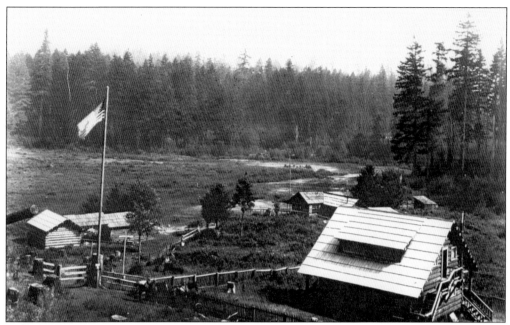

DAVIS RANCH. In 1906, Jahu Davis homesteaded 160 acres of land between Three Lynx and Austin Hot Springs (above). To gain title, he was required to live on the land, clear it, and fence part of it. Davis built a house on the land and lived there for over five years. His younger children stayed on his farm in Garfield so they could attend Garfield school. Shown at left, the US Forest Service built a ranger station manned by forest rangers Sharp (left) and Paxton, pictured here, until 1922. Portland Railway Light & Power Company purchased the property on November 14, 1921. A labor camp and sawmill was set up on the 52-acre homestead to cut railroad ties, lumber, and timbers for use in the construction of a new dam near the Oak Grove fork of the Clackamas River and Three Lynx Creek. (Both, PGE.)

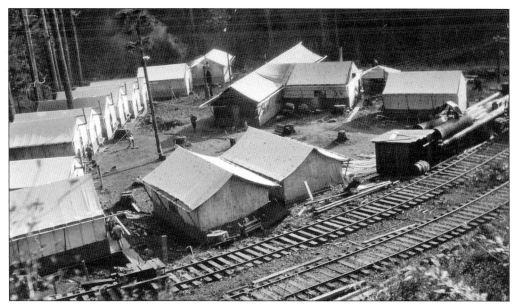

TENT CITY. Workmen building the dams on the Clackamas River could not travel to the site from Estacada every day, so they were housed in tents with wooden floors, referred to as "contractor towns." They were not quite like home, but PRL&P did its best to provide good meals and basic amenities in dormitory-style quarters. (JR.)

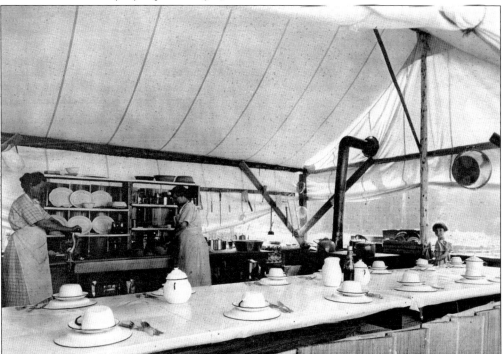

GOOD FOOD, 1922. All camps had a cookhouse with a kitchen and dining room like this one at Davis Ranch. The only women at the camps were cooks and waitresses. According to an old story, men on the crew stuffed hotcakes in their shirts, calling them "liver pads," and then called out for more; the women were miffed and went on strike for a couple of days. (PGE.)

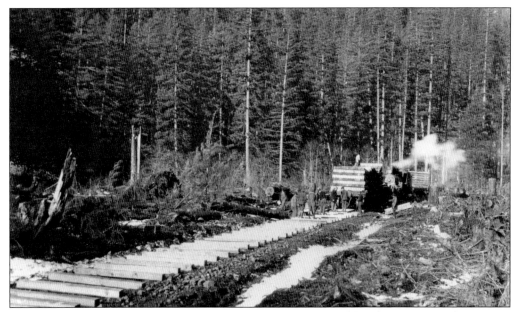

RAILS, FEBRUARY 1923. PRL&P realized that a railroad would be the most expeditious way of transporting people and equipment to the Oak Grove construction site and beyond. This photograph shows a crew laying track for a railroad just below the area known as "red rock." The ties were cut and planed at the sawmill at Davis Ranch. When the tracks were removed in 1937, a road was built on the rail bed. (PGE.)

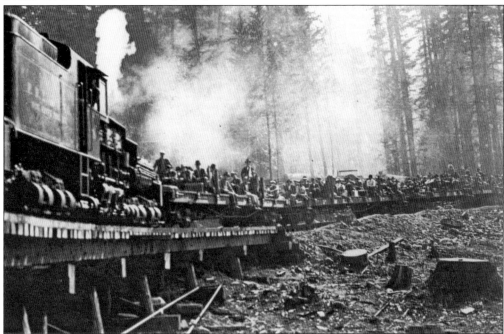

TRANSPORTATION, 1923. Soon, a Shay engine, pulling freight cars, carried workers to different parts of the Oak Grove project. The men had to work outdoors in all weather. Even so, riding in the open air on the cold October morning seen here had to be an uncomfortable start to the day. (PGE.)

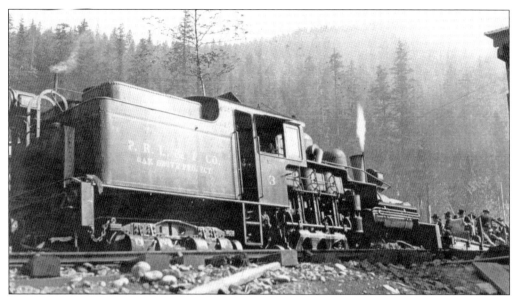

WORK HORSE. The Shay was the favorite locomotive of the construction workers. It was a heavy-duty engine with enormous power driving the wheels. Its short wheel base made it ideal for confined areas, and it could operate on hills two to three times as steep as those that a rod engine could handle. (PGE.)

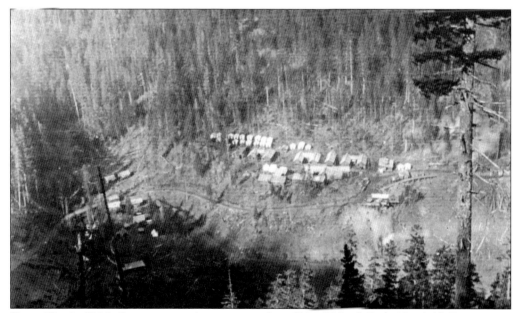

CAMP NO. 8, 1923. Construction sites were numbered No. 1 North Fork; No. 1 1/2 Promontory Park; No. 2 South Fork; No. 3 Lazy Bend; No. 4 Moore Creek; No. 5 Fish Creek; No. 5 1/2 Fish Creek Campground; No. 6 Roaring River; No. 7 Three Lynx turnoff; No. 8 Three Lynx; No. 9 Cripple Creek; No. 10 Davis Ranch; No. 11 Station Creek; No. 12 Canyon Creek; No. 13 below Lake Harriet; and No. 14 Lake Harriet. This is a photograph from the hillside across Clackamas River. (PGE.)

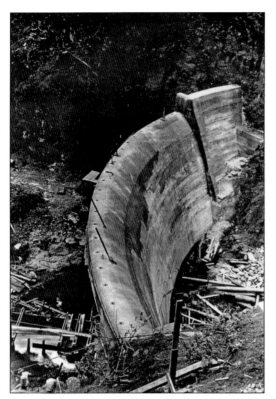

GRAVITY FEED. In 1924, PRL&P became Portland Electric Power Company (PEPCO), which built an arch dam atop the mountain, above the powerhouse. Water travels eight miles down through a nine-foot-diameter pipe, or penstock, with enough force to turn the turbines. The lake was named after company president Franklin T. Griffith's daughter, Harriet. This photograph was taken looking down and toward the left abutment. (PGE.)

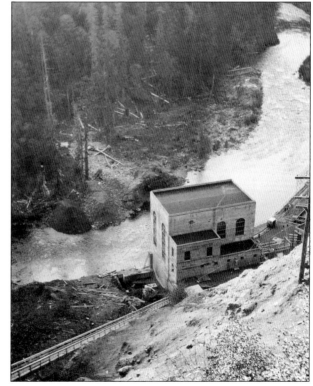

TAKING SHAPE. Hurley Mason was the contractor for the Oak Grove Powerhouse, and construction moved smoothly under his guidance. This photograph of the building as it neared completion was taken above the powerhouse, looking down from the hillside below Lake Harriet. (JR.)

STEP UP. The pipe coming down the hill had to be regularly examined for leaks. A set of stairs was built from the powerhouse all the way up to the pipeline's west portal and surge tank. The employee assigned to climb these stairs must have been in great physical shape. No one remembers the exact number of steps, but the estimate is around 2,000. (PGE.)

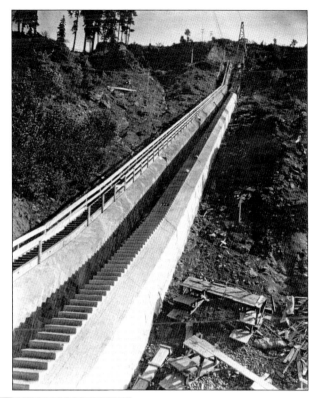

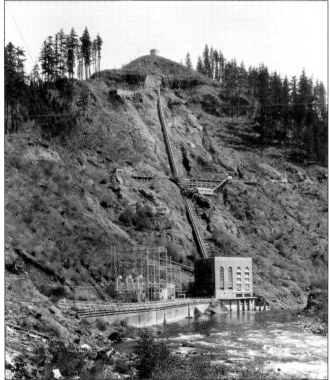

BARE HILLSIDE. Trees quickly grew on the hill, obscuring this view of the penstock and stairs. In this photograph of the completed powerhouse, the pipe rises at what appears to be a very sharp angle. Looking at it from this viewpoint and thinking about the man climbing up, a person could become quite breathless. (PGE.)

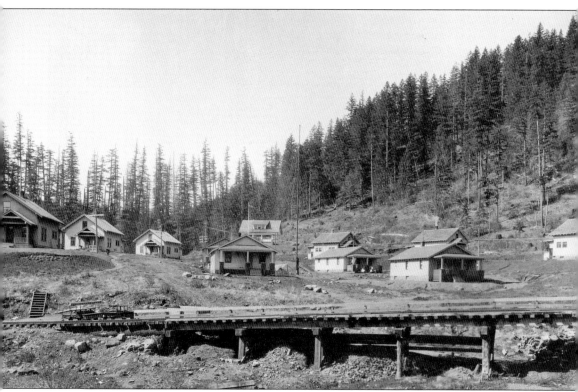

THREE LYNX. Oak Grove was too far from Estacada for workers to travel every day. In 1922, the company began upgrading Camp No. 8 by building permanent employee housing. Eight cottages were built using traditional methods. Additional houses were purchased from Aladdin Readi Cut Homes and assembled on-site. These kits consisted of pre-cut lumber, a heating system, lighting fixtures, bathroom and kitchen fixtures, and finish materials. PGE supplied the labor and some of the materials for the foundation and plaster. The Estacada School District sent teachers to educate the dam employees' children. This 1930 photograph corresponds to a 1931 map showing 18 individual dwellings plus the school, a guesthouse, a bunkhouse, a cookhouse, and a speeder train shed. The speeder train, a motorized version of the old handcar, delivered groceries and other supplies from Estacada to the settlement's residents. A sense of community is inherent here. Three Lynx is one of three remaining company towns in America, and its buildings are eligible for listing in the National Register of Historic Places. (PGE.)

HIGH WATER. In 1996, a powerful wall of water rushed down the Clackamas River toward Estacada. The cause was a heavy snowpack in the mountains that melted rapidly after a dramatic increase in temperature combined with days of steady, heavy rain. Almost overnight, the river rose above all recorded levels, and the easy-flowing river turned into a surging monster that threatened to swamp everything in its path. The Oak Grove Powerhouse (visible on the left side of both photographs) was nearly inundated, but the raging current crested within feet of the powerhouse floor. The flood caused serious damage to land and buildings all the way down the Clackamas to the city of Portland and beyond, but the Oak Grove generators kept sending out power. (Both, JR.)

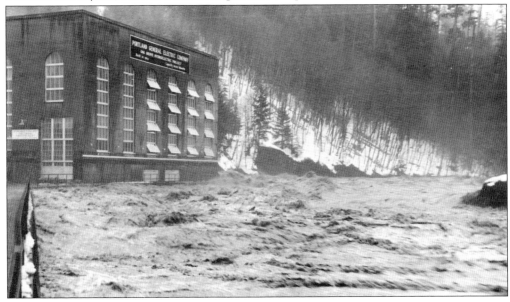

OUR PRIZE FATHER AND SON PICTURE

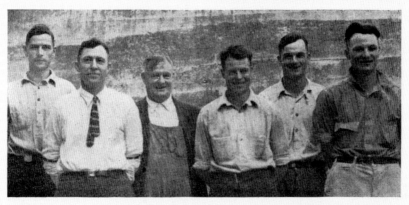

Reading from left to right: Grover, Clifford, John, Everett, Theodore and Otto Kuggins.

When we started collecting the information and pictures of the fathers and sons who are employed by the company, we little expected to find such a prize group in one family as the one pictured on this page. We thought it quite exceptional to find at least fifty fathers and sons working for the company but when we discovered this group, a father and six sons, we immediately claimed a record and should some firm duplicate this record, we still have another card to play—there is also a step-son working for the company.

All members of this group are employed in the Light & Power Department and that department would like to have the Railway Department produce anything nearly as good. The father, John Kiggins, is a wheel tender at River Mill; Grover Kiggins is flume foreman; Clifford is relief operator at Stations "G" and "M"; Everett is an oiler; Theodore works on the flume; Otto is a wheel tender, and D. E. is a gate tender up at Intake. That is the reason his picture is separate from the group. Uncle Willie Foster had to make a special trip to get his picture and he says it is a long, long way, and the weather isn't so warm up in the mountains.

We should also like to have a little more co-operation from some of the fathers and sons whose pictures we have been unable to secure. We do not want to slight any one and should like very much to complete the entire list. Please get in touch with Foster, Vickrey or Brace in the Electric Building.

D. E. KIGGINS

Oh, Woodman!

A poplar tree with burnished leaves
 That twinkled in the sun,
Stood tall and straight upon a hill,
 With many another one.

The heart-shaped leaves with scalloped rim
 Each had a flattened stem,
So every lightest breath of air
 In passing, fluttered them.

The trees are gone; the hill is bare
 Except for ugly stumps;
They were destroyed that we may read
 The annals of the Gumps.

LIKE FAMILY. The building of the dams on the Clackamas River is responsible for the formation of the city of Estacada, and many residents contribute to the maintenance of the dams. It seems that most of the residents now work for Portland General Electric, worked for PGE in the past, or have relatives who worked for the company. In 1929, PGE identified 50 fathers and sons who were employed there. That year, the company's in-house magazine, *PEPCO Synchronizer*, included an entire page devoted to John Kiggins and his six sons. All of them were employed in the light and power department. From left to right, in the group photograph, are Grover, flume foreman; Clifford, relief operator; John, wheel tender (and father to the other men); Everett, powerhouse machinery oiler; Theodore, flume maintenance; and Otto, wheel tender. Douglas Eugene "Gene," gate tender, was unavailable for the group shot; he is in the separate photograph at lower left. (PGE.)

Five

BUILDING ESTACADA

LOOKING SOUTH ON BROADWAY, 1959. This postcard showing the business district reads, "ESTACADA, OREGON. This bustling city on the banks of the Clackamas River and near some of Oregon's finest forests, make this an important lumber and logging center while serving many thousands of fishermen and campers during the summer." (RK.)

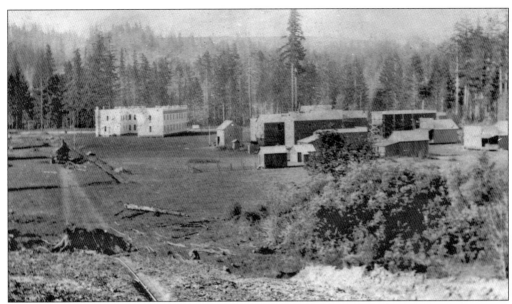

AVAILABLE. Before the arrival of the railroad, this was empty land. The investors in Oregon Water Power Railroad Company capitalized on the rails to Cazadero by building a splendid park and offering a grand hotel to accommodate guests. The Estacada Hotel is in the left background of this photograph, which was taken on top of Reagan Hill. The trees in the background grew along the banks of the Clackamas River. (WSG.)

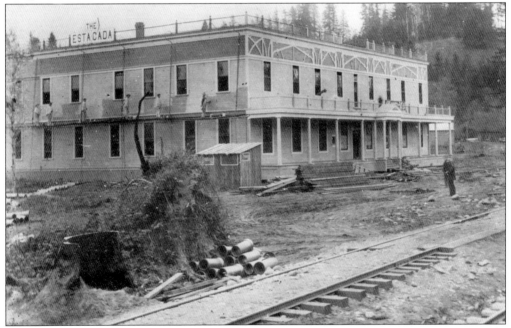

NEARLY FINISHED. The hotel was resplendent with natural woods; furniture of precious woods, wicker, and bamboo graced its 47 rooms. Once construction was completed, in 1903, advertising material published by Oregon Water Power & Railway Company touted the hotel as "a modest, homelike, and comfortable inn, where the visitor may make his home and headquarters during his vacation." (WSG.)

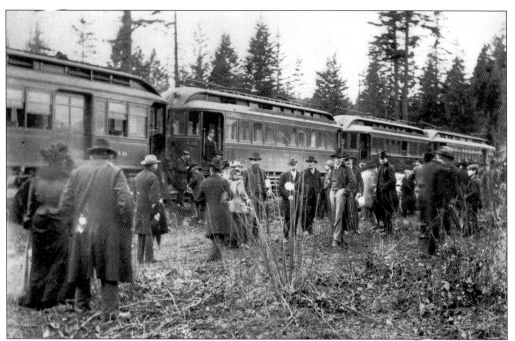

BIRTHDAY, JANUARY 12, 1904. Dignitaries from OWP&R, the Oregon Water Power Township Company, and representatives from the governments of the city of Portland and State of Oregon traveled on the new railroad line. Here, they return to the coaches after a ceremony marking the beginning of the town of Estacada. (WSG.)

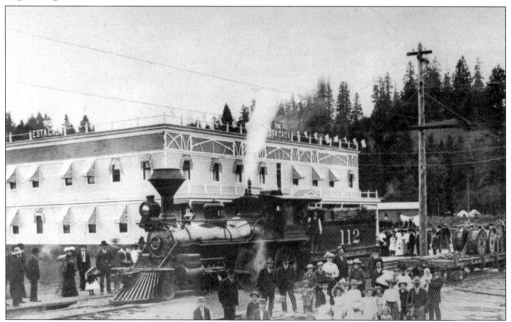

HOLIDAY, 1904. Travelers taking the train from Portland disembarked beside the Estacada Hotel, which was the town's prestigious landmark, hostelry, and restaurant from 1903 until 1929. The Tucker and Closner families, in the foreground at right, were among those who greeted visitors as they arrived to celebrate Independence Day at Estacada Park. (MF, NT.)

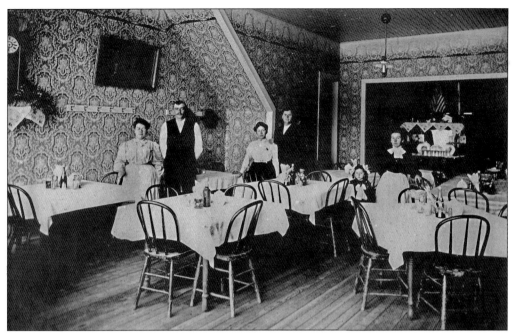

DINING ROOM. Inside the hotel, the Portland Restaurant was family-run. From left to right are Anna Tucker Marchbank, John Marchbank, Wilda Tucker Lindsey, Al Lindsey, and helpers Mary and Vita. One specialty referred to in the advertising was the "freshest of eggs laid each day by the hens in the coop behind the hotel." (NT.)

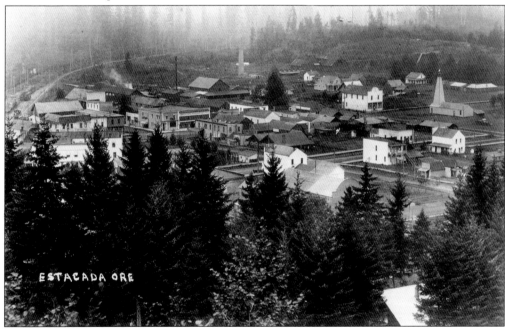

OVERVIEW OF ESTACADA, 1904. Taken from the top of Reagan Hill, this photograph shows, on the far right, the distinctive tower sitting atop the combination city hall and fire department and the chimney of the brick yard rising in the center background. The railroad curves around the left side of the photograph. (BH.)

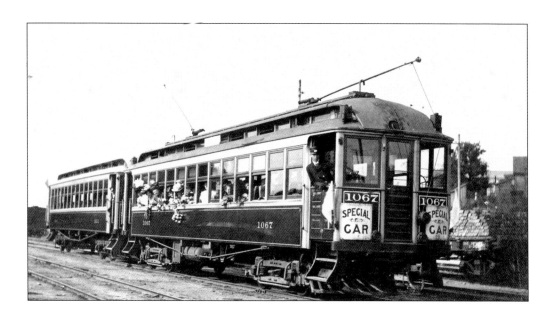

TROLLEY TRAFFIC. At one time, it took five trolleys a day to carry all the visitors to the city. The largest group was a Portland employees' picnic in 1922; attendees arrived on a four-car electric train for baseball games, sack races, music, dancing, and strolling through the park. Stairs led down to the water, where fishermen were rewarded with plentiful trout. As automobile travel increased and interest in the railway waned, OWP&R sold the parkland to the Portland Telegram Subscription Department. Summer cabin lots, measuring 20 by 100 feet, were sold for $35 and a two-year subscription to the newspaper. A ticket for passage between Portland and Estacada is shown below. (Above, MF; below, JZH.)

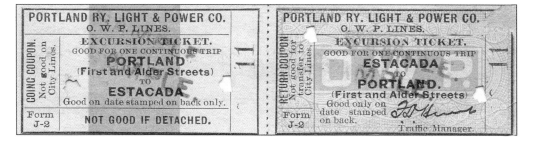

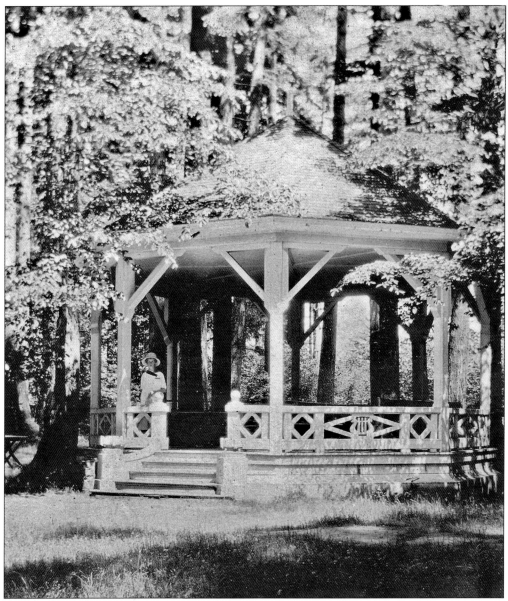

ESTACADA PARK. The 60-acre park extended west from the covered bridge, along the Clackamas River all the way to the future site of River Mill Dam. A path traversed the entire length, providing a view of the Clackamas River rapids for those who came for excursions or parties. Both visitors and locals posed for photographs under the lovely arched entrance to Estacada Park. Welcoming visitors for the first time in October 1906, the park was a valuable attraction until 1922. The gazebo in this photograph was built as a venue for local musicians to entertain picnickers with summer concerts, but it was also a romantic setting for lovers. During a trip from Barton in 1918, Grace Ruth Ferrel posed inside for a photograph. A pavilion adjacent to the gazebo housed a piano and "masks for dancing parties." (RL.)

BRIDGING THE CLACKAMAS.
The first bridge, built in 1859 with trees felled across the river, broke down completely when a herd of cattle was driven across it in 1862. The second bridge, a low wooden structure, provided settlers heading for the gold fields of California with access to a road that passed through Springwater and Viola—an easier route than the one to Oregon City. (NT.)

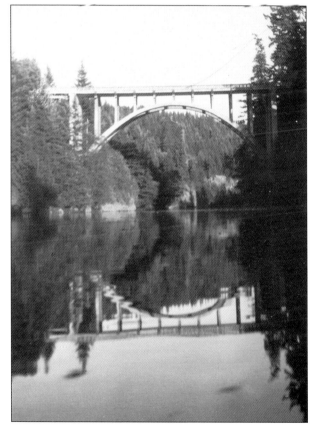

FOURTH AND CURRENT BRIDGE.
Today, the reflection of this beautiful concrete structure is mirrored in the now placid waters of the Clackamas River. It replaced the third bridge across the Clackamas, a covered structure that was engineered by J.W. Reed. The current bridge was constructed just downstream to the west from the old covered bridge. Estacada residents gathered for its dedication as part of the Labor Day Celebration in 1936. (JR.)

ABOVE ESTACADA IN WINTER. Hard winters with heavy snow were common. This picture looks down the hill on Broadway Street. When snow created travel problems, the street was closed to everything except sleds. A party often followed these closings, with neighbors gathering around bonfires between runs down the hill. Sometimes people poured water on the road to make the slope icier for even more exciting rides. (MF.)

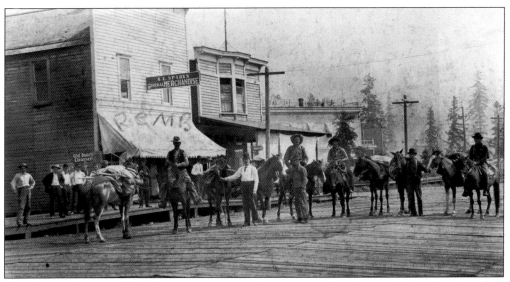

NEW PLANK STREET, 1910. On a sunny day, packhorses, shoed by blacksmith J.V. Barr, lined up in front of A.E. Sparks Merchandise. US Forest Service firefighters and workers used horses to pack into the forests around Estacada. The new three-inch wood planks installed on Broadway Street made travel much easier than it had been on the muddy surface. (MF.)

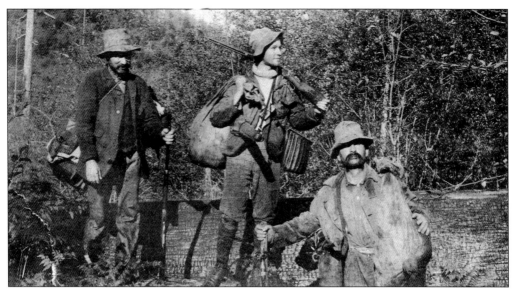

PACK WOMAN. In this image, it appears that Charles and Robert Miller were beginning a trek upriver and would want to take all the supplies needed to set up camp. There is no packhorse in sight, but it seems that their sister Annie, whom they invited along, helped by carrying more than her share of the load. (MF.)

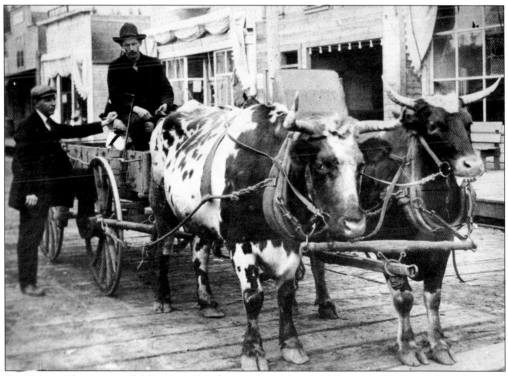

OX TEAM. These powerful beasts of burden were used to haul logs down skid roads and to pull wagons laden with up to a half-ton of grain or fruits to the gristmills. A good ox could cost $30 or $40. Frank Howard (left) admires Fred Nitchman's prized yoke of oxen as they stand on the planks of Broadway Street. (JZH.)

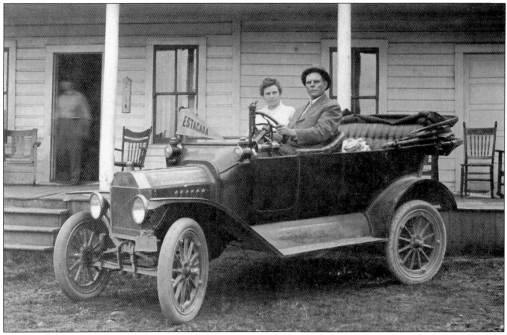

THE AUTOMOBILE. The horse and wagon gradually gave way as preferred transportation, as long as the newfangled machine could make it up a hill with a 20-percent grade, through 18 inches of mud, or plow through the sticky clay mix from Viola down Clear Creek to Fischer's Mill. After trying out several brands, J.W. Reed, shown here with his wife, came to prefer the Ford Motor Car. (JZH.)

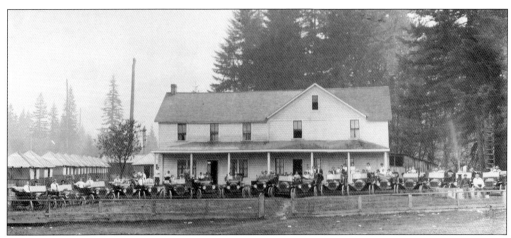

FORD MOTOR COMPANY WINS. In 1915, J.W. Reed announced another arrival of automobiles. Residents were expected to spend $100 on cars that season. Reverend Aue of Springwater bought one and retired his famous horse, Billy. This type of loyalty helped Reed excel as the owner of the first Ford agency in Estacada. He hosted a picnic in Welches, pictured here, to celebrate the sale of the first 18 Fords. (JZH.)

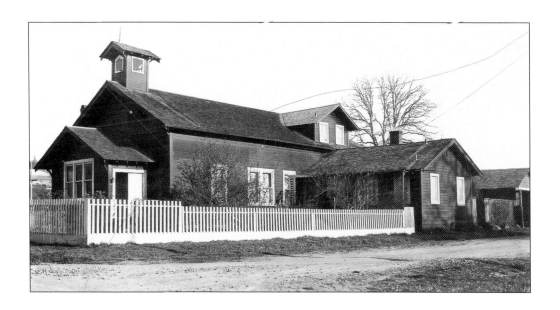

LOAVES AND FISHES. The original St. Aloysius Catholic Church was built in 1924. Inside, the altar, with an intricate carving of the Last Supper, was surrounded by statues of Jesus, angels, and St. Aloysius. During the difficult World War II years, Fr. William Delplanche ("Father Bill") provided for parishioners by harvesting fish (out of season) at Eagle Fern Falls. Using a method called the "Dupont Spinner," he placed a stick of dynamite inside a glass jar, lit the wick, closed the lid, and threw the jar into the pool below the falls. When the dynamite exploded, Father Bill picked up the dead salmon and steelhead. The game warden came running, but when he saw Father Bill, he deliberately turned away as though he did not see a thing. (Both, JH.)

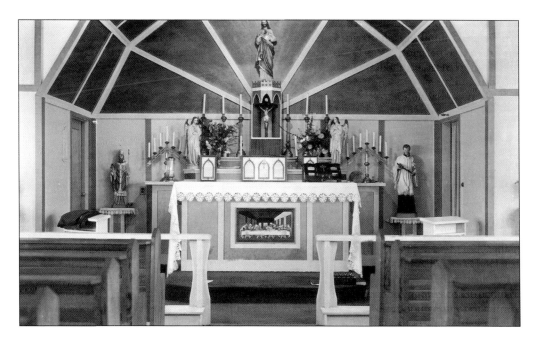

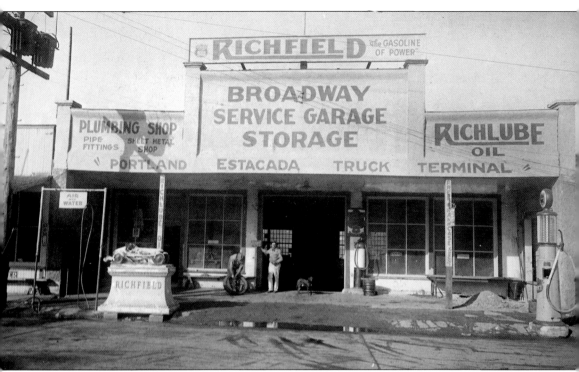

Bus Depot. Abraham "Abe" Ames stands in the doorway of his Broadway Service Garage. Mechanics filled automobiles with gasoline from the pump (right) and air and water (hoses at left) and handled vehicle repairs. The man to the left of Ames may be fixing a tire. The small race car on top of the pedestal is an advertisement for Richfield, "the gasoline of power." Ames owned the garage, but spent most of his time in his plumbing and metal workshop next door. Across the front of the garage is "Portland Estacada Truck Terminal." A small, Greyhound-type bus entered the building from the rear and exited onto the street in front. This photograph was taken in the late 1920s or early 1930s. A hardware store was to the left, and on the corner up the street was a small house that held the Estacada Library. Ames was town constable at the time River Mill was under construction and he told of how rough the town was back then. Ames served as mayor of Estacada for two terms beginning in 1947. (DK.)

THE LIBRARY LADY, 1919. Hattie Saunders (second from left), known as "the Library Lady," spearheaded the formation of the first lending library in Estacada in the early 1900s; many women with young children banded together, pooling their own books to fill the shelves. This Saunders family photograph shows Hattie's husband, John "Andy," with Hattie and their children, Lucile (left), Ivan, and Ruth. (BH.)

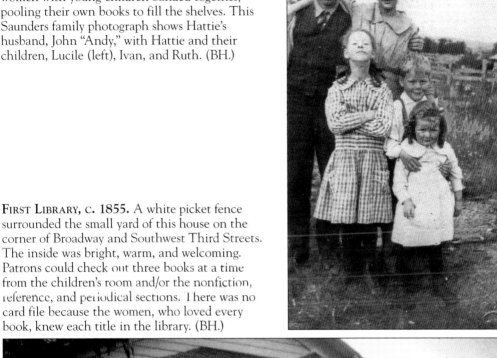

FIRST LIBRARY, C. 1855. A white picket fence surrounded the small yard of this house on the corner of Broadway and Southwest Third Streets. The inside was bright, warm, and welcoming. Patrons could check out three books at a time from the children's room and/or the nonfiction, reference, and periodical sections. There was no card file because the women, who loved every book, knew each title in the library. (BH.)

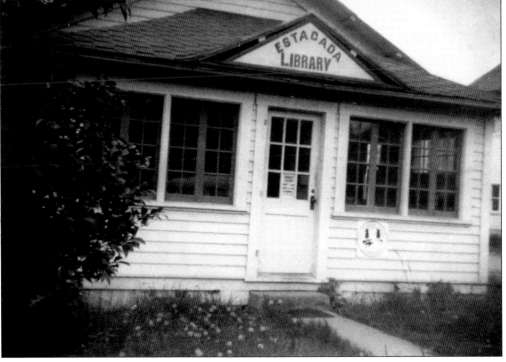

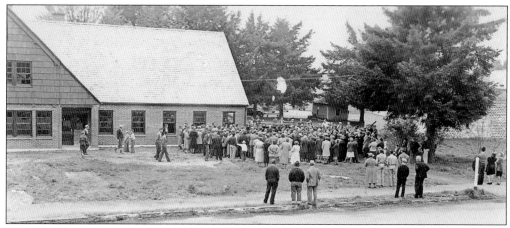

NEW CITY HALL. Pres. Franklin D. Roosevelt's Works Project Administration (WPA) paid people to construct municipal buildings during the Depression. This beautiful brick edifice, erected in 1938, was also a new home for the library, which moved into the south end, with its large windows and fireplace. The fire department took the north end, with three bays in the back. Here, residents gather for the dedication. (JZH.)

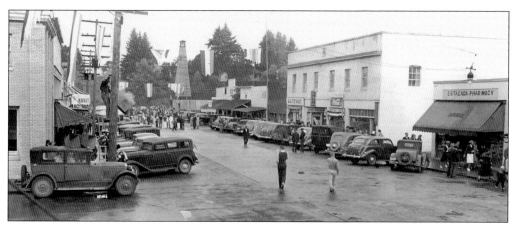

HOLIDAY, 1938. In this image, a parade is about to take place. Judging from the speakers on the roof of the car, the fellow on the telephone pole at left appears to be setting up a sound system. People are gathered at the far end of the street. The wet pavement suggests recent rainfall, which would be no surprise on the Fourth of July or Labor Day. (WS.)

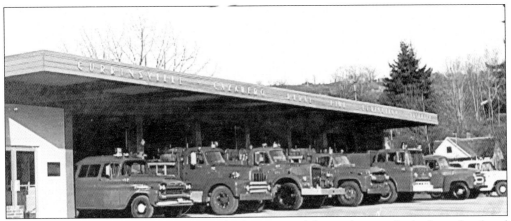

FIRE STATION. In 1964, a new station, which was grand for its day, was built through a bond measure. A bell tower held the original fire bell and siren. Other features included inside water pipes for filling apparatus (rather than having to hook up to a hydrant), a public entrance, a large front pad to ease the daily checks of fire apparatus, and a service shop with an exhaust removal system. (EFD.)

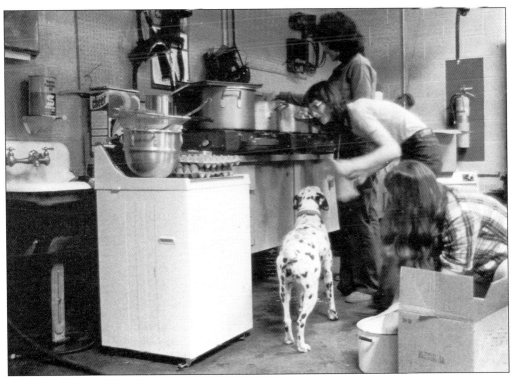

NEW DIGS. After years of operating from the second floor of City Hall, the new single-floored station was pure convenience. Here, two people are busy preparing what may be Easter eggs, under the watchful supervision of a traditional Dalmatian fire dog named Spot. (EFD.)

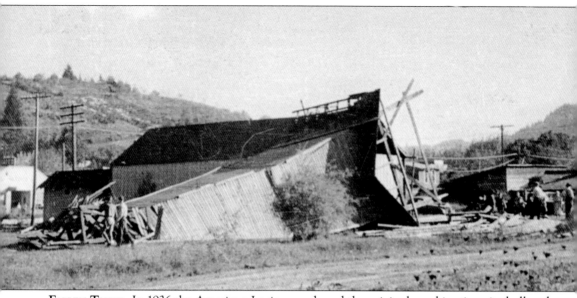

FALLEN TOWER. In 1936 the American Legion purchased the original combination city hall and fire station for $1. This photograph recorded the demise of the building that was built in 1907. Whether it fell or was pulled is unclear, although a cable might be visible. The building was distinctive because of the tower which was constructed to house the fire bell at a height that would carry the sound to the upper level of town. It also turned out to be a convenient place to hang hoses to dry. But on this autumn day, the distinctive tower lay broken on the ground. All that was left was cleanup and the memories of days gone by when the bell high at the top rang out the children's curfew at 9:00 p.m., to call members of the city council to meetings, or to alert the populace that firemen were needed to extinguish a blaze. (WS.)

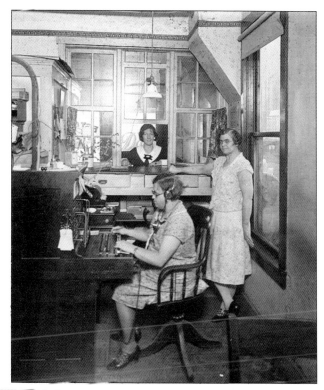

ON THE LINE, 1940. Telephone service began as a cooperative in Estacada in 1905. To place a call, one turned a crank on the right side of the phone, which contacted the operator working a PBX switchboard. Going through an operator continued after the introduction of dial telephones. This photograph was taken inside Cascade Telephone and Telegraph; co-owner Maud Smith is in the background near the window. (RC.)

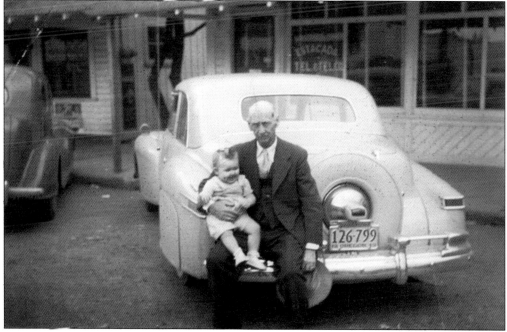

ALVA SMITH, 1949. Alva and Maud became majority stockholders of Cascade Telephone and Telegraph in 1924. After 22 years at the helm, the Smiths handed the reins to their daughter Neva and her husband, Floyd Day. The Day family has been in continuous ownership ever since. Neva and Floyd were followed by their son Duane, and now by his daughter, Brenda Crosby. (RC.)

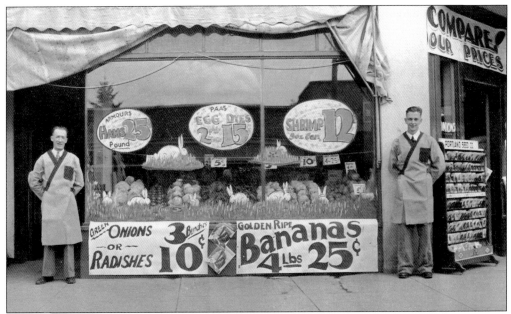

STOREFRONT, 1940. These unidentified Safeway clerks were ready to provide year-round personalized service, even though windows and advertised specials changed with the season. Around Easter, fresh produce was welcomed and holiday hams were featured together with shrimp to add a tropical touch to salads. At right is a seed display. (JZH.)

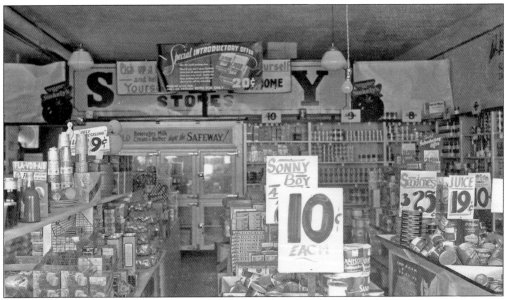

INSIDE SAFEWAY, 1940. The large, modern supermarket offers greater variety, but a housewife shopping here could pick up all essential ingredients for her well-planned family meals. Customers often carried their own baskets to gather the groceries and to carry them home. Canned and packaged foods were the standby, but milk, butter, eggs and ice cream were stocked in the refrigerators in the left rear of this photograph. (JZH.)

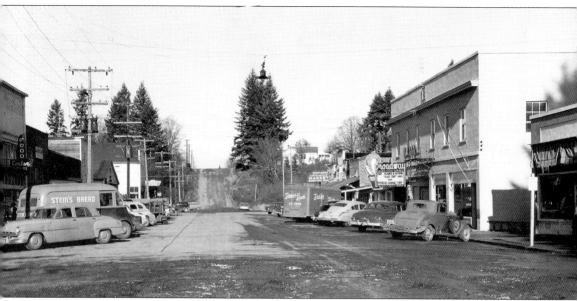

LOOKING NORTH ON BROADWAY, 1949. At left, Stein's Bread delivery truck is parked in front of the Food Center. Sparks General Merchandise was next door. Phillips Variety and a shoe shop were in the Odd Fellows hall. At right, Mae Rose's Department Store, a former bowling alley, sold women's clothing in one section and men's clothing in the other. The Broadway Theater marquee lists the airplane action thriller *Flat Top*, on a double feature with *Tarzan's Savage Fury*. Down the alleyway to the right of the theater were Marchbanks Confectionary and the US Army Enlistment Office. The barbershop of Millie Kiggins was next to the theater. Farther up on the right, Peter Pan Ice Cream was being delivered to Campanella's Market, where customers could shop for groceries, meats, and produce. (BH.)

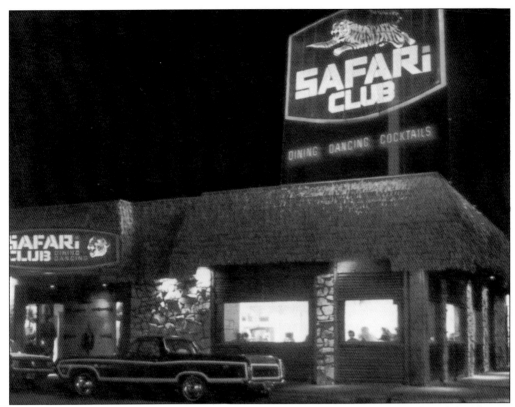

SAFARI CLUB. Expert marksman and big game hunter Glen Park opened the Safari Club, filling it with 100 animal trophies he personally collected that were preserved by taxidermy. The dioramas brought hordes of visitors to Estacada, from Girl Scout troops to Oregon governor Mark O. Hatfield and his family. This postcard read: "It's a dining treat and unique experience to visit the Safari with its colorful displays of wild life from all over the world presented in life-like detail." In the office, heads and skins surround Glen (seated) and his son Mike. Advertising handouts included cocktail napkins, matchbooks, business cards, jacket patches, even a faux $1,000 bill with Glen's picture. Glen was determined to be the best, and excelled in everything he tried. (Both, JP.)

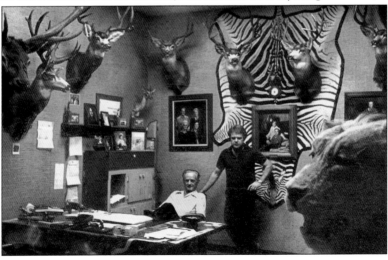

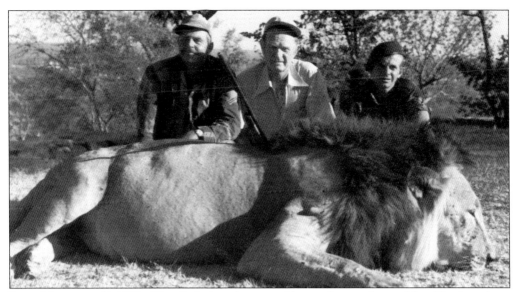

LION, NOVEMBER 7, 1973. Glen Park shot the second-largest lion in the world in Rhodesia (now Zimbabwe), Africa. Like many of his trophies, which included both grizzly and polar bears, the lion was placed in a diorama exhibit in the Safari Club. Park wanted animal species to survive (with the exception of the ones he personally killed); over his lifetime, he donated many dollars to the preservation of animals. (JP.)

SABLE. Although Glen Park was the adventurer, his wife and children often accompanied him on expeditions to various parts of the world, and his son Mike rode with him on hunts. This photograph of Glen (right) and Mike, documented a sable shot in southern Africa, in what is now the Republic of Botswana. (JP.)

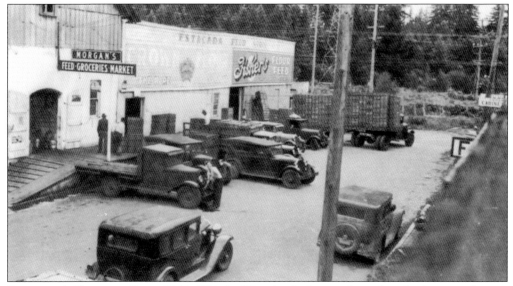

ECKERSLEY'S FEED AND SEED, 1962. This building backed up to the railroad, where goods were moved from the loading dock onto the freight cars and vice versa. Farmers brought fruit harvests for pick-up. Although there were other owners, the Eckersley family ran this business from 1962 to 1968. (SB.)

COBBLER, 1985. For over 40 years, Sam Haines repaired shoes for customers in Estacada, taking pride in stitching and stapling and making a pair of logger boots look brand new again. For a time, his shop was on Main Street, across from city hall, but his permanent shop up the hill was once used as a ginseng dryer. Here, he teaches the trade to his one-year-old grandson Isaac. (RS.)

Six

INTO THE WOODS

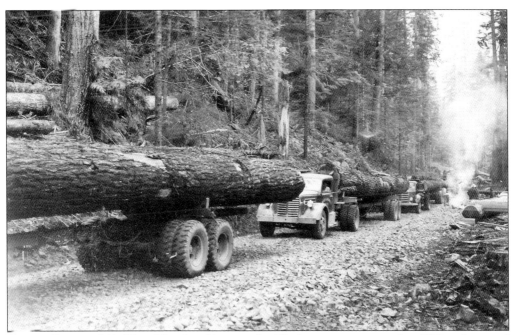

ON THE ROAD, 1942. The old railroad line up the Clackamas was removed in 1937 and a gravel road was built on the rail bed. Dwyer Logging Company trucks lined up to bring one log each out of Fish Creek and down the Clackamas River Timber Access Road (later renamed Highway 224). (CW.)

TRANSPORTATION. Glen Park, pictured here, used his airplane to check out timber, to consult with sellers and buyers, or to meet with government officials. Bob Dwyer sometimes landed at the Park Lumber airfield on the flight up to the Fish Creek camp to pick up his employee and Garfield resident Jake Wolcott. (JP.)

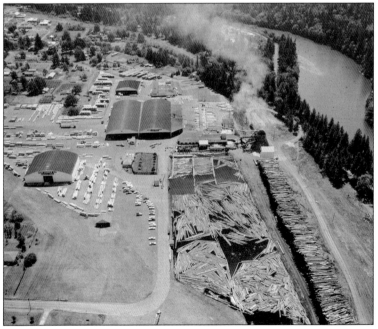

AIRPLANE VIEW. This photograph gives an overview of the Park Lumber plant. It shows the airstrip, log pond and cold deck, log handling facilities, debarker, drying shed, and kiln. A chipper was installed near the burner for greater log utilization. The plant employed 60 men, which contributed to the business of the community. During the year 1959, the plant ran 22 million board feet. (JP.)

LOTS OF PULL. Steam donkeys were placed on log frames—called skids—and set in the middle of a logging operation in progress. Cables running from the donkey were attached to a log, pulling it in to where it could be loaded on a truck. Ted Scott and Charlie Richards manned this donkey on skids. (RF.)

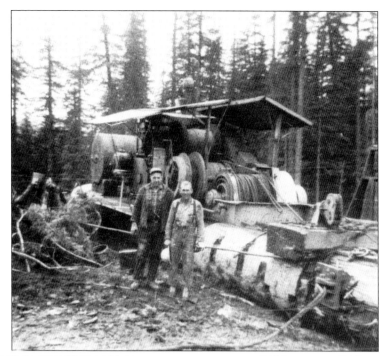

THE TRAILS, 1969. When there was work available, word went out that anyone interested should meet at this tavern in the morning, and many loggers were hired from here. In the afternoon and evening, the Trails was a place for relaxation and libations after a day in the woods. Pictured here are, from left to right, Mike Perry, Don Hasse, Ted Scott, Merle Brenton, and Charlie Richards. (JR.)

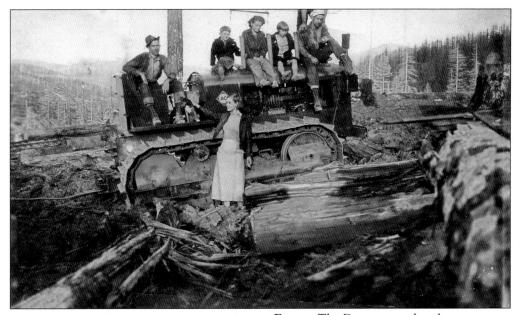

FAMILY. The Dwyers were hands-on owners. Rosemary Dwyer frequently flew up to Fish Creek camp to see what was going on. The Dwyers' employee Charlie Whitten sits in the driver's seat of the Allis-Chalmers tractor he drove to corral the logs. His children are lined up on the hood, and Rosemary, who was never afraid of logging dirt (even while wearing a dress), stands in front. (CW.)

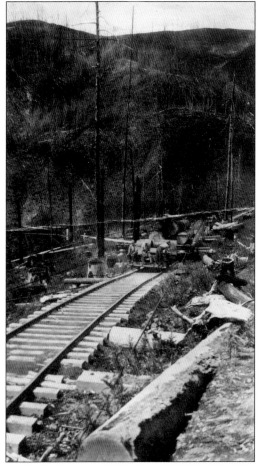

DISASTER. On September 12, 1929, a fire broke out at the end of LaDee Ridge. An east wind was blowing and flames roared down North Fork Canyon, down Squaw Mountain and Delph Creek, and swept over Garfield. The fire destroyed the Log LaBarre resort, homes, cabins, barns, automobiles, and the Garfield School. Burned snags surround the rail car pictured here. (CW.)

A Sight. These motorists took a nice Sunday drive up the mountain. What they saw was the result of the LaDee fire. Giant snags stand as naked sentinels over the once green hillside. The vast area affected by the flames is evident in this photograph, and scores of years later the blackened fir trees killed that day were still visible amid the new growing trees. (JZH.)

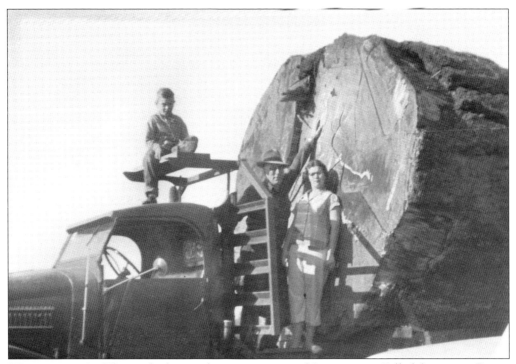

Whopper, 1954. This is the biggest log to come out of Springwater. Felled far out on Raney Lane, it measured 10 feet and 4 inches by 10 feet and 6 inches. According to Frank Lowe's mill in Molalla, this log produced 11,000 board feet. Here, Bill Tucker Sr. stands with his hand on the log, with daughter Nancy beside him. His son Tucker perches on the rack atop the cab. (NT.)

WOODPILE. The wood-burning stove was the predominant source of heat in houses, schools, churches, and businesses on the West Coast. Stockpiling wood for winter was a necessity. It is said that gathering wood warms a person eight times—felling, sawing, splitting, loading, unloading, splitting, stacking, and burning. Hugh (left) and Bill Ferrel are pictured here in Barton at the beginning of the process. (RL.)

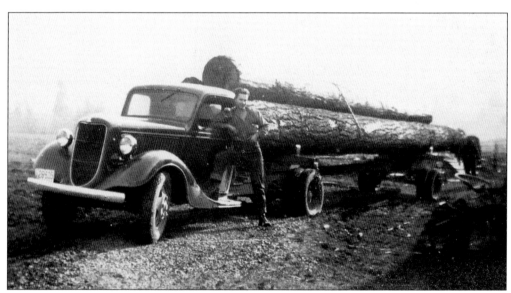

COMPARISON. Logging companies continue to harvest along the Clackamas, and even though the loads are just as heavy, the timber they cut is younger and smaller. The old one-log loads gave way to three-log loads like this one driven by Jack Whitten. By today's standards, these logs would be considered pretty big. (CW.)

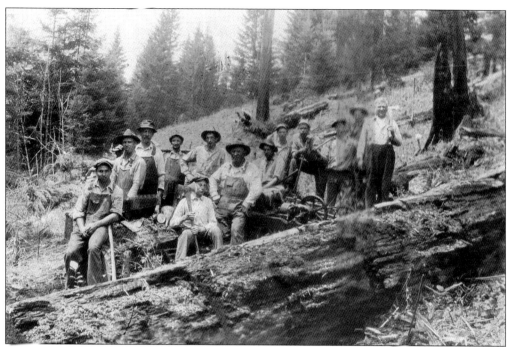

Felled. Members of the Miller family in George were prominent in the logging industry. This outfit operated in the forest up on Fall Creek. Here, Adolph and Leslie Miller (on far left), other family members, and the crew pose with one of the big trees they felled in 1918. (MF.)

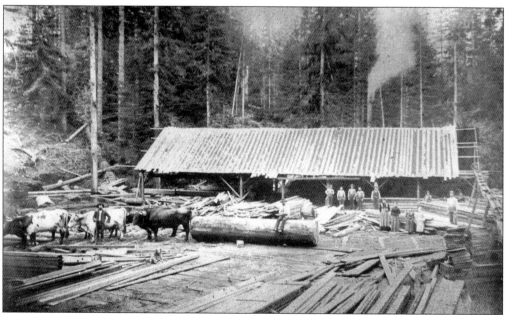

At the Mill. Oxen pulled the logs to the Miller Saw Mill at Fanton, near the top of Squaw Mountain Road, where the timber was cut and planed into boards. The lumber was then loaded onto a horse-drawn wagon, which traversed a winding, rut-filled dirt road near the top of the mountain to the town of George. Most of the barns in the town were built from that wood. (MF.)

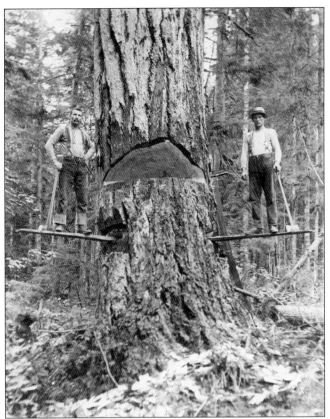

SPRINGING UP. To rise up the tree, the faller cut a notch as high up as he could reach and placed a springboard five to six feet long, nearly flat, with an iron tip in one end, into the notch to stand on while cutting. On large trees, two men could springboard up to approach the job from two sides. Springboard notches are still evident on older logged stands. (JZH.)

BUSINESS. Al Lindsey and brothers Robert, Charles, and Adolph Miller were all experienced in running mills. Aware that commercial production could be a moneymaker, they decided to join forces to construct this mill. They maintained a crew of 20 or more to handle the influx of logs. (NT.)

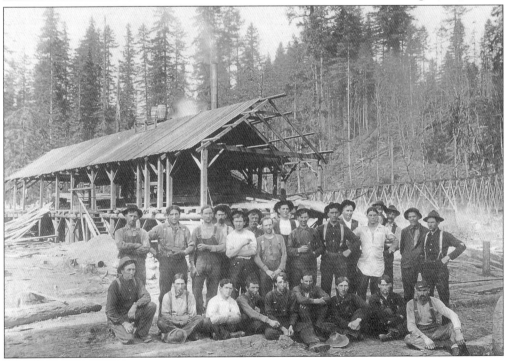

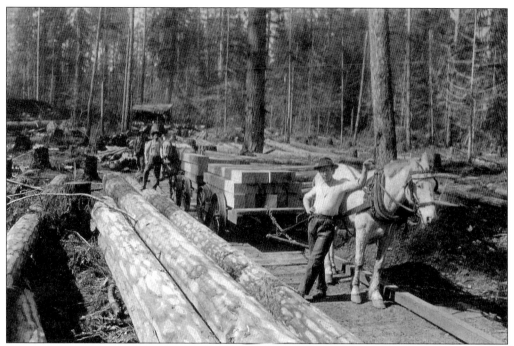

ABOVE THE MUD. In the rainy Clackamas area, there was plenty of muck as the trees fell and were dragged across the ground. Although oxen were used to pull logs over skid roads, these men laid planks on top of the mud to create roads that would carry a wagon heavy with beams. (JZH.)

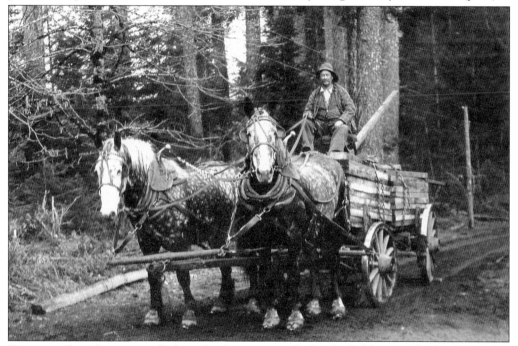

DELIVERY. Once logs were milled into lumber, someone had to load, deliver, and unload the order. R.W. Akins made a living with his fine pair of draft horses pulling the load on a cart. Here, he heads down the road with a load of logs fresh from the mill. (BA.)

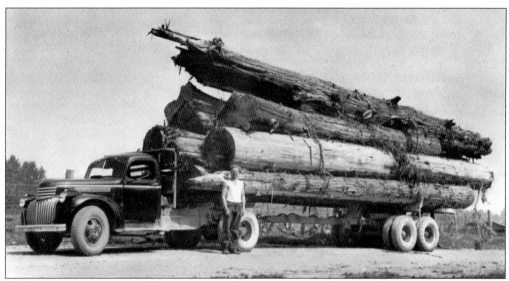

HEAVY, 1942. Glen Park stands beside a bumper load of logs he brought into the mill during the heyday of logging in Clackamas County. This haul would turn into a good supply of lumber, but the load—13,631 board feet—would be too big for today's public road limits. (JP.)

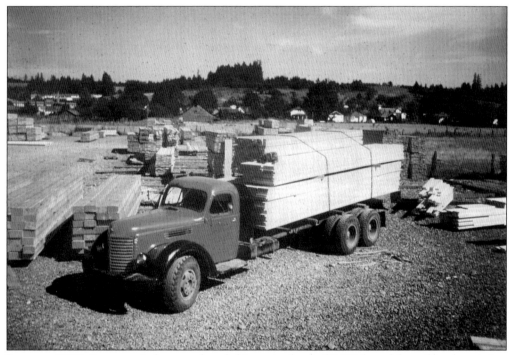

LOADED, 1968. Just two timbers produced this entire load of 2,100 board feet of lumber sitting in Park lumberyard, ready for delivery at a cost of $420. This same year, Glen Park appeared in front of Sen. Wayne Morse and other members of Congress as a witness from the lumber industry during hearings on the problem of log exports to Japan. (JP.)

104

Seven

EVERYTHING THAT GROWS

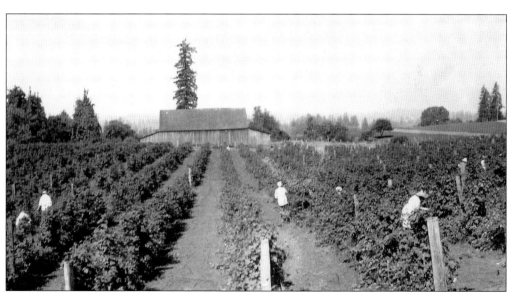

SWEET, 1920. Canneries and makers of jams created a market for the newest cash crop when they put out word that they needed all kinds of fruit. Libby, McNeil Company offered a contract to growers of loganberries in Springwater. Strawberries were shipped from Garfield to Sandy to be made into Smucker's jam. (WSG.)

SCRATCH. Mother Martha Tucker, Branch Tucker's wife, feeds her chickens on the family farm. Every family raised chickens for eggs and to serve as an entree in a delicious Sunday dinner. Once the railroad made daily runs from Estacada to Portland, many farmers shipped fresh eggs to the big city's restaurants. (NT.)

ON THE SLOPE. Gus Burnett chose to raise goats on this Eagle Creek hillside. These animals are sure-footed and independent and survive on plants they find along the hillside. The rams take good care of others in the herd. Goats are easier to keep than sheep, and their milk is good for drinking or making delicious cheese. (JZH.)

WOOLLY, 1949. For a few years, Joseph Guttridge raised sheep. He belonged to the Pacific Wool Growers, which had a ready market for everything he produced. He received a letter commending him for shearing and delivering early. One of the hardest parts of raising sheep is protecting them from the coyotes. (WSG.)

TURKEYS, 1945. Some families raised beef or sheep for sale, but the Ferrel family, in Currinsville, chose to raise turkeys. Sales were brisk around the holidays. The birds did well outside as long as they had troughs full of Albers feed, green leaves from sunflowers, and a shed for shelter. (RL.)

PENNIES FOR HOPS. Lydia Ruhl earned a penny a pound picking hops at one of two Anderson family farms located on the land between Currinsville and Barton. Legend says that some workers pushing carts of hops up the long ramp to the second-floor driers fell off the ramp, perhaps because they had already sampled the product. After drying, the hops were transported to the Blitz-Weinhard Brewing Company in Portland. (MF.)

A TEAM OF THREE. A team of draft horses was an essential part of farming. With them, a man could plow a field, bring in a wagonload of hay, or haul logs. Draft horses were gentle and dependable by nature, and willingly worked lengthy hours. Ed Fickens is pictured with Jim (left) and Barney. (DCF.)

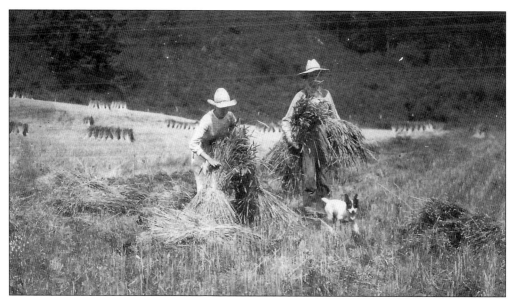

SHOCKING GRAIN. A farmer who was a father expected his children—both boys and girls—to pitch in at harvest time. At left, his daughter ties the shock so it will stand alone to dry in the field, while his son gathers another load. The rat terrier with them was extremely popular in rural areas because it was adept at keeping barns and sheds free of vermin. The names of the farmer and his children are not identified on this photograph. (MF.)

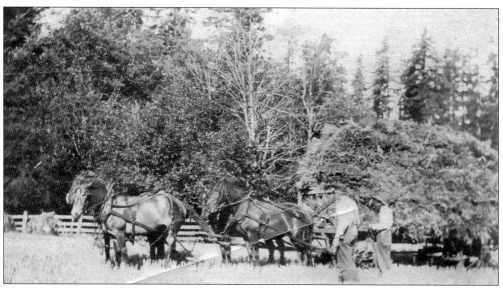

HIGHER, 1925. James A. Shibley (left) and William Bard load bundles of wheat to an unbelievable height on the wagon. This was a banner year, and it took five pounds of twine to tie all the bundles—the usual amount would have been two pounds. The harvest was too much for one team; it took two teams to get the load to the barn. (WSG.)

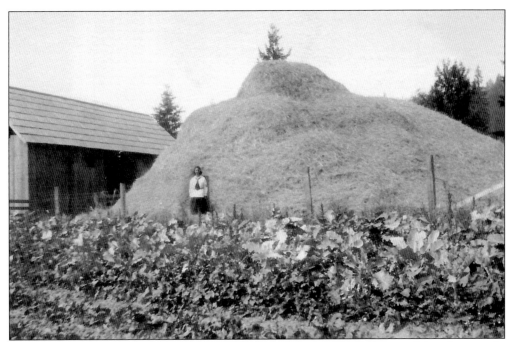

MOUNTAIN. A huge mound of grain dwarfs the unidentified girl in the center of this photograph. After the wheat was taken to the mill, it could make a fine batch of whole wheat bread, pancakes, or great bowls of cooked cereal. (MF.)

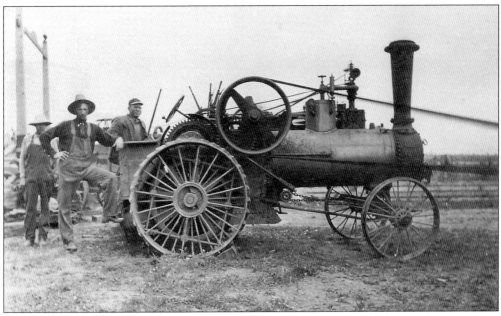

IN CHARGE. Adolph Miller, leaning on the thrasher, was the engineer of the threshing machine in George. All sorts of things could happen, like a piston coming loose, falling into the crankcase, and bending the connecting rods, which meant parts to buy and lost time. Additionally, the oil on these old threshers had to be changed every three hours. (MF.)

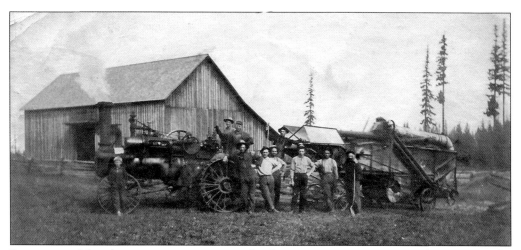

Important. After the steam engine operator, the three most important men on the crew were the ones who fed the thresher. They set the pace, and the rest had to keep up carrying the bundles to the machine. With Uncle Adolph (sitting on top of the thresher) in charge, the boys were sure to do it right. The names of the men and which position each man held is not noted on the photograph. (MF.)

Rounding Up. The advent of the tractor meant a comparative life of ease for the farmer. Instead of following the horse, the baler followed him. Now, instead of tense shoulders, this unidentified man will get a stiff neck. The Millers, in Viola, rolled their newly mown hay and left it in the field to dry. (MF.)

DRYING. Fescue grass was the money crop on the Guttridge farm in 1955, and the seed had to be dry or it would mold. These farmers adopted an ingenious drying method—sacks full of seed were hoisted to the top of the barn and spread out on the roof to dry in the sun. The sacks are visible on the barn in the upper left of this photograph. (WSG.)

SPOT SPRAYER, 1965. Grass seed had to be 98-percent pure and free of weeds. Here, William Perry, the lead person (right), wears a belt with an attached rope. When he walked forward, the rope pulled a lever that released a spring, which in turn released the brake, and the V belt let the trailer move forward at about 10 miles per hour. When Perry stopped, the trailer stopped. Darrel Gentemann was his helper. (NT.)

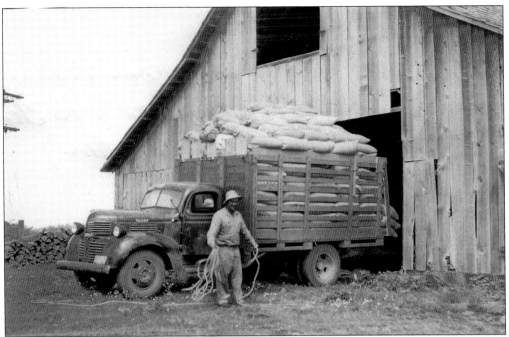

COILING ROPE. William H. "Bill" Tucker loaded his truck with fescue grass seed and prepared to leave. He coiled a long line of rope so that he could throw it across the load and tie it down to hold the bags in place while he traveled. He hauled the seed to Pohlens, a seed-cleaning mill in Redland. (NT.)

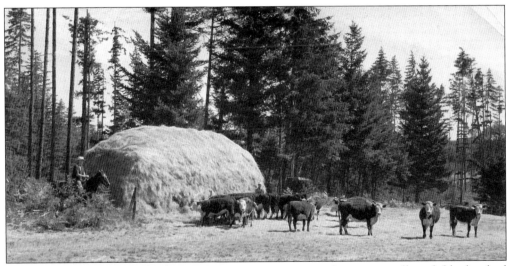

ALTA FESCUE. Growing Alta fescue grass was a savvy move, for it grew well on fields that had been depleted after years of raising grain crops. Another benefit was that Alta fescue hay had some nutritional benefits for cattle and so could be sold as pasture grass. The Shibley family took advantage of that with their Herefords, shown here. (WSG.)

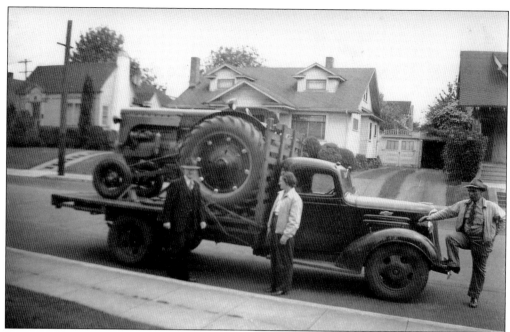

STUCK. Bill Tucker (right) delivered this new Minneapolis Moline "Z" tractor to Molalla, and his wife, Theda Boyle Tucker (center), and father-in-law, Harry Boyle, came along for the ride. When Tucker tried to back the tractor off the truck, he discovered that the men at the distribution center had only put in enough gas to get it on the truck. (NT.)

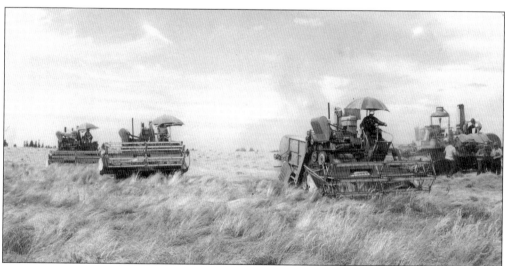

FASTER. Bill Tucker was the man to see for Minneapolis-Moline farm equipment. The first combine harvesters, introduced in the mid-1930s, revolutionized the cutting of crops. These machines cut a 12-foot-wide swath, and utilizing multiple harvesters, as seen here, meant finishing a harvest quickly so that men could spend less time away from their own farms. (NT.)

Eight

INTERESTING EVENTS

TRICK DOG. Many unusual things happened on Main Street in Estacada, but none as comical and endearing as Bob Scott's dog. There was no parade on the day this picture was taken, but heads turned to watch the pooch as he demonstrated one of his best tricks. He was obviously happy to show off. (BH.)

SPRINGWATER FAIR, 1951. The Grange put on the first Springwater fair in September 1923, preceding the Clackamas County and Oregon State Fairs. Over 600 people attended the first fair. The Grange hall contained exhibits of the finest examples of produce, fancy needlework, and schoolwork. Oregon governor Walter M. Pierce came, giving a lecture on "Equalization of Taxes." This group awaits the award ceremony. (WSG.)

HOMEMAKING SKILLS, 1951. Women entered quilts, clothing, and knit socks and hats. Judges tasted pies, cakes, breads, and other baked goods. Mary Horner supervised the canning exhibit, with its peaches, beans, pickles, and other fruits and vegetables. Judges picked the ones that were most colorful, uniformly sized, and evenly packed in their jars. Winners were given blue, red, or yellow ribbons. (WSG.)

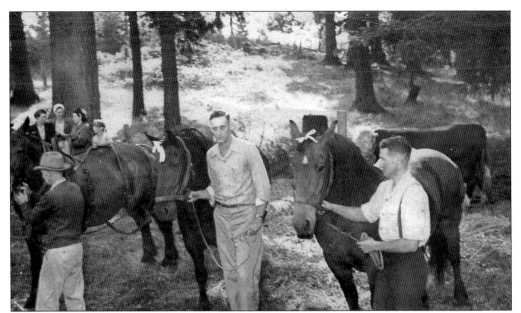

A TEAM, 1946. "Testifying to the fertility of the soil and the skill of the farmers," judges determined the best food crops and livestock—including poultry, cattle, swine, sheep, and horses—and awarded ribbons to first, second, and third places. Joe (left) and Dick Guttridge showed their draft team, Trixie and Queenie, groomed to perfection and decorated with ribbons in their manes; they took the blue ribbon. (WSG.)

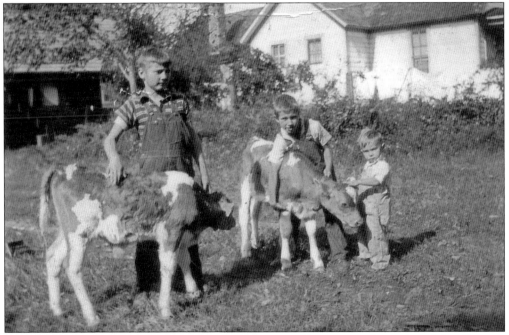

PRACTICE, 1939. Livestock exhibitions at the Springwater Fair were not limited to adults. Growing up on the farm, youngsters learned about animal husbandry, including how to show cattle. Here, three Shibley boys—Elwin (left), Jimmie (center), and Gilbert—practice presenting Guernsey calves in the show ring. (WSG.)

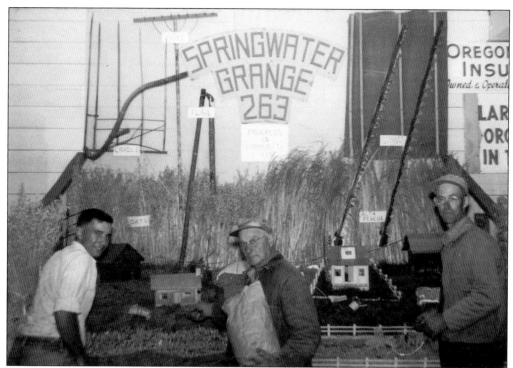

COUNTY FAIR, 1952. Many farmers with years of experience at the Springwater Fair entered the Clackamas County Fair, showing their livestock for judging. They also used booths to advertise their farms. Members of the Springwater Grange participated by constructing a replica of the Guttridge farm and everything it produced. Manning the booth are Jim Shibley (left), Ray Miller (center), and Les Hamilton. (WSG.)

EVERETT SHIBLEY SHOWING BIG ARTHUR. Shibley raised Guernsey milk cows for years, but in the 1940s, he sold them and started raising purebred polled Hereford cattle. For the rest of his life, he raised 40 to 50 calves every year. In 1953, Shibley was honored as Cattleman of the Year in the state of Oregon. (WSG.)

VORTEX 1. In August 1970, Pres. Richard Nixon was scheduled to speak at the American Legion national convention in Portland. The Portland-based People's Army Jamboree announced that it would hold a concurrent event to protest the war in Vietnam. The FBI reported that an estimated 25,000 Legionnaires and 50,000 antiwar demonstrators could clash. Fearing that radicals might incite violence, a few Portland hippies suggested a free rock concert outside Portland to draw potential demonstrators out of the area. Gov. Tom McCall designated McIver State Park, near Estacada, as a place to hold the concert. Between August 28 and September 3, more than 100,000 people attended the event. Some arrived in motor vehicles while others walked from the town of Carver, nine miles away. Use of illegal drugs, such as marijuana and mood enhancers, was permitted. Gov. Tom McCall instructed local and state law enforcement officers to leave attendees alone. (LM.)

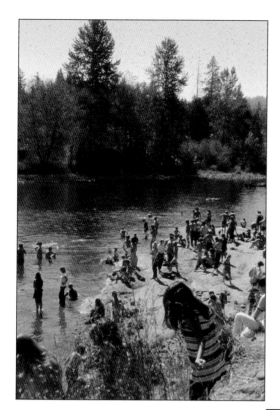

VORTEX OF POSITIVE ENERGIES. The Clackamas River provided recreation as well as a means for bathing, boating, or cooling off. A medial center treated injuries, as well as drug reactions. The Oregon Air National Guard's first emergency helicopter airlift took a man suffering from an LSD overdose to a hospital. (LM.)

TOGETHERNESS. This was the first time the word "biodegradable" was used in connection with a human event. Everyone joined in preparing meals and keeping the grounds clean. There was never an instance of unrest among participants. Those involved in overseeing the event found their cooperation commendable. (LM.)

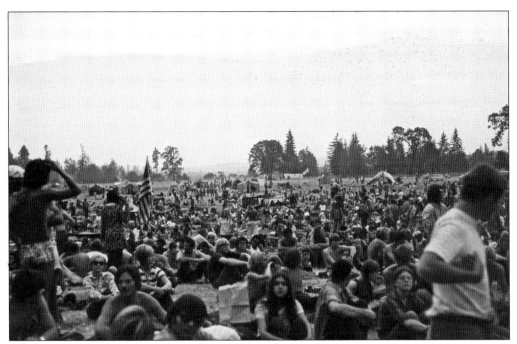

STAGE WITH A SOUND SYSTEM.
Musical groups performed day and night. Local bands dominated the bill. Celebrity musicians such as Notary Sajack, Tu-Tu, Jacob's Ladder, Portland Zoo, Mother Smucker's Jam, Children of Moo, Good Clean Fun, Gene Redding and Funk, Charles Musselwhite, Brown Sugar, and blues musician Paul Delay appeared on stage. The music went on until 2:00 a.m. or 3:00 a.m., when members of the audience retired. (LM.)

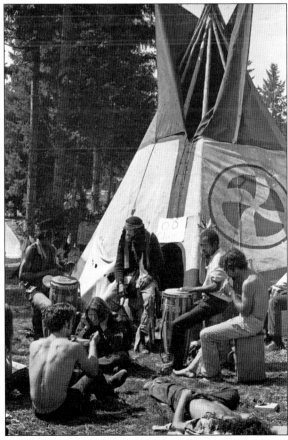

PEACE AND MUSIC. This was a peaceful expression of human community. People slept in tents or under the open sky, joining together to play instruments and talk. On Sunday morning, preachers held religious services on the performance stage. At the festival's end, Gov. Tom McCall visited the park, hugged some hippies, and then joined them in chanting some "oms" and reciting the Lord's Prayer and a few lines from William Blake. (LM.)

TIMBER FESTIVAL. In the beginning, loggers competed in demonstrations of logrolling, log-bucking, and topping of live trees that grew on the banks of the lake. By 1970, the 116-foot-long poles used for climbing demonstrations had to be brought down from the mountains by the US Forest Service. These were firmly planted into the festival grounds so that 100 feet remained above ground level. (JR.)

FESTIVAL COURT. Pretty girls are always a joy to admire, which may be why festivals and even schools, at homecoming, want a court. Residents of the city of Estacada, as well as all surrounding towns, picked girls to compete for the title of "Timber Festival Queen." These young women were picked as the princesses. The handwritten names on the back of the photograph simply say, "Marge, Mabel, Dyhurt." (JZH.)

THE BAND. Before the dance, carnivals, fireworks, and food came the parade, with Ruth Cousins on her tractor, the Estacada Volunteer Firemen showing off the new engine, and Morris Tuttle driving his truck full of logs. One float, entered in the Portland Rose Festival Parade, held a giant logger. Here, the Estacada Union High School Band proudly marches past the Ford Garage. (JZH.)

EQUINES. Horsemen of all ages proudly showed off their prize horses. Horse clubs demonstrated what they were learning about riding. In 1981, 83-year-old Everett Shibley (left) rode with his friend Tom Bard. This was Shibley's last appearance in a parade. He suffered a fatal heart attack only weeks after this ride. (WSG.)

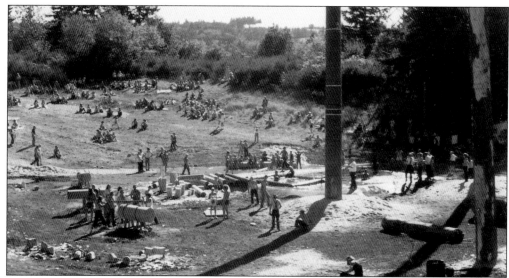

THE COMPETITION. The main event at the Timber Festival was the logging competition, with demonstrations of log-bucking, logrolling, using springboards, and tree-climbing using straps and spurs. Prizes were awarded to whoever completed the task in the fastest time. At the 1970 festival, international tree-climbing champion Kelly Stanley thrilled the crowd by climbing a spar tree and defying death by dancing "the twist" on the treetop, which measured just 12 inches across. (LH.)

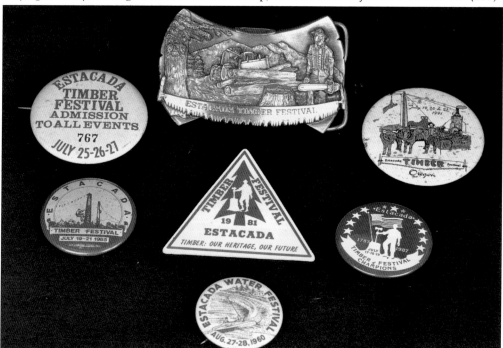

MEMENTOS. People of all ages attending the Timber Festival wore T-shirts emblazoned with the emblem chosen for that year. Purchasing a Timber Festival button for $1 granted admittance to all festival activities. Most people threw their buttons away after the event, but Jack Reynolds kept his intact. In addition to 22 buttons, his collection includes several festival T-shirts and a commemorative belt buckle. (JR.)

MINSTREL PLAY. This photograph shows what was, for its time, an accepted form of local entertainment. Vaudeville entertainers such as Al Jolson performed in blackface, singing spirituals and rousing numbers such as "Swanee" or "Waiting for the Robert E. Lee." (JZH.)

WORLD WAR II. The US Army Air Force built a watchtower next to the Red & White Store. Observers had to demonstrate that they could identify all American and foreign aircraft by their silhouette after studying *Identification of Aircraft*, a page of which is seen here. After undergoing intensive training, 12-year-old Wilma Guttridge amassed an amazing 254 hours as a member of the Aircraft Warning Service. (WSG.)

SECTION III

SHAPE—UNDERNEATH VIEW

37. The underneath view of an aircraft's wings is even more helpful than the front view for purposes of identification. There are five major classifications of wing shape from the underneath viewpoint, which may be found in various combinations. They are: Straight, Sweptback, Tapered, Rounded Trailing Edge, and Elliptical.

Straight
O–52 (U. S. Army Observation)

Sweptback
Douglas Transport (U. S. Army and Commercial Transport)

Tapered
A–20 (U. S. Army Bomber)

Sweptback and Tapered
Messerschmitt 110 (German Fighter)

Rounded Trailing Edge
O–46 (U. S. Army Observation)

Elliptical Trailing Edge
P–47 (U. S. Army Fighter)

476792°—42——2 13

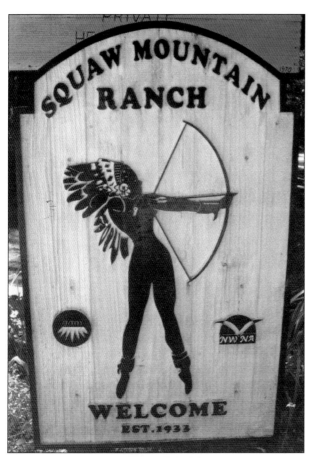

MUSIC FESTIVAL. Bands playing rock and roll, jazz, and blues are featured each year during the third full weekend of August at Squaw Mountain Ranch. Past programs have included professional musical impersonators of singers like Elvis Presley. Squaw Mountain is the oldest nudist club west of the Mississippi. Clothing is optional for those attending the concerts. (SMR.)

HOORAY! What a birthday party it was. This was just what the citizens of Estacada look forward to—another parade. At this event in 1948, there was an opportunity to wear pioneer dresses and bonnets or fringed vests and coonskin caps and march in the Oregon Centennial Parade. Dressing up is always fun. (NT.)

BIBLIOGRAPHY

Bowman, Sylvia Eckersley. *Days Gone By: History of the Estacada Area*. Estacada, OR: self-published, 2007.

EDAW Team. *Portland General Electric Westside Cultural Resources Study*. Seattle, WA: Edaw, Inc., 1998.

Old Times Festival Association. *Estacada*. Estacada, OR: Estacada High School journalism class, 1955.

Oregon Historical Quarterly, Vol. 28, March–December 1927: 53–56.

Love, Matt. *The Far Out Story of Vortex I*. Pacific City, OR: Nestucca Spit Press, 2004.

Rosenkranz, Patrick. *Looking Back: Old Times in the Estacada Country*. Estacada, OR: published by students at Estacada Middle School, 1979.

Shearer, Margaret E. *A History of Springwater Grange*. Estacada, OR: self-published, 1993.

DISCOVER THOUSANDS OF LOCAL HISTORY BOOKS
FEATURING MILLIONS OF VINTAGE IMAGES

Arcadia Publishing, the leading local history publisher in the United States, is committed to making history accessible and meaningful through publishing books that celebrate and preserve the heritage of America's people and places.

Find more books like this at
www.arcadiapublishing.com

Search for your hometown history, your old stomping grounds, and even your favorite sports team.

Consistent with our mission to preserve history on a local level, this book was printed in South Carolina on American-made paper and manufactured entirely in the United States. Products carrying the accredited Forest Stewardship Council (FSC) label are printed on 100 percent FSC-certified paper.

MADE IN THE USA